A History of Chesapeake

A History of
Chesapeake
Virginia

Raymond L. Harper

Published by The History Press
Charleston, SC 29403
www.historypress.net

Copyright © 2008 by Raymond L. Harper
All rights reserved

First published 2008
Second printing 2011

Manufactured in the United States

ISBN 978.1.59629.351.9

Library of Congress Cataloging-in-Publication Data

Harper, Raymond L.
a history of Chesapeake, Virginia / Raymond L. Harper.
p. cm.
ISBN-13: 978-1-59629-351-9 (alk. paper)
1. Chesapeake (Va.)--History. I. Title.
F234.C49H36 2007
975.5'523--dc22
2007044401

Notice: The information in this book is true and complete to the best of our knowledge. It is offered without guarantee on the part of the author or The History Press. The author and The History Press disclaim all liability in connection with the use of this book.

All rights reserved. No part of this book may be reproduced or transmitted in any form whatsoever without prior written permission from the publisher except in the case of brief quotations embodied in critical articles and reviews.
I dedicate this book to my wife of fifty-eight years, Emma Rock Harper; to our two daughters, Shari and Karen; and to our three grandchildren, Alexa Raye, Colby John and Collin Steven Rudis.

Contents

Preface		7
Acknowledgements		9
Introduction		11
Chapter I	The Chesapeake and Jamestown	15
Chapter II	The War for Independence	23
Chapter III	The War Between the States	29
Chapter IV	Local Education	37
Chapter V	Early Tidewater Religions	47
Chapter VI	South Norfolk	55
Chapter VII	Washington	77
Chapter VIII	Pleasant Grove	97
Chapter IX	Butts Road	111
Chapter X	Deep Creek and the Dismal Swamp	119
Chapter XI	Western Branch	133
Chapter XII	A New City Is Born	145
Bibliography		157
About the Author		159

Preface

Thirteen years have passed since I wrote my first book. It was a self-published paperback history of South Norfolk consisting of 182 pages without images of any kind. My plan was to print only four or five copies and give them to friends that had provided me with information. That is exactly what I did; however, the story does not end there. After reading their copies, the original owners began to lend them to other people and they immediately wanted copies of their own. To make a long story short, the effect was like a snowball rolling downhill. The demand began to grow. After selling about 250 copies I found that I had accumulated enough cash for an updated version with photographs.

Copies of the revised edition were ready by October 1996. The first copy went to Mrs. Lucy Mortenson, a member of my church. Lucy received her copy on October 19, 1996. By December 31, 1996, I had sold more than two thousand copies right out my front door. People wanting books rang my doorbell on Christmas Eve and also on Christmas morning. Copies of my first two books were never sold in the local bookstores.

Acknowledgements

Most of the older citizens who contributed information and pictures for my original self-published histories have since died. Without their help and kindness I would not be writing this book. Over these past thirteen years I have met many people and become friends with most of them. They have all helped me in one way or another. I could not have done it without them.

In addition to those kind people, I would like to express my sincere appreciation to the following persons who contributed their services, knowledge, information and photographs used in this volume:

Linda Boyette, nursing supervisor, South Norfolk Health Center; W.W. Colonna Jr., chairman, Colonna Shipyard, Inc. (retired); Jimmie Davis; Eric Feber, *The Virginian-Pilot*; Larry Floyd, Virginia State Police (retired); Ernest Fulford; Charles Hackworth, Hackworth Reprographics Inc.; Robert B. Hitchings, Norfolk Public Library; Phil Johnson, Chesapeake Arboretum; Dr. Raymond T. Jones, vice-president, public radio services, WHRO; Myrtle Lambert, Chesapeake School System (retired); Sue Anne Loonam, Historic South Norfolk; Victor and Lori Pickett, owners of the Happer House; Portsmouth Central Library; Burnie Mansfield, plant manager, La Farge Cement Plant; James E. Rich (now deceased); Mary Lou Rock; Colby Rudis; Jeffery T. Sadler, Coastal Group, Inc.; Mark Shea, Chesapeake Planning Department; Marlyn Shumaker, public health nurse (retired); Stuart Smith, Chesapeake Police Department (retired); Winston Smith, Chesapeake Sheriff Department (retired); Richard Sprately; G. Paylor Spruill, Crestwood Homes; Roxanne Stonecypher, who furnished information about the Dismal Swamp; Frankie Sweetwood; W. Troy Valos, Norfolk Public Library; and Ben White, City of Chesapeake Economic Development Department.

I am also indebted to the folks at The History Press for agreeing to publish this book about the city of Chesapeake. I hope it will be well received. "Thanks guys."

Introduction

Although the city of Chesapeake is in its forty-fifth year, it is still one of the newest cities in the Commonwealth of Virginia. There are many newcomers to our area and those who are too young to know that the city of Chesapeake originated from the merger between the city of South Norfolk and the remains of Norfolk County on January 1, 1963. I use the word *remains* because Norfolk County once included most of the land that is now the cities of Norfolk, Portsmouth and Chesapeake.

In 1872, the city of Norfolk was squeezed between Smith Creek on the north and Newton's Creek to the east. You might say it was landlocked because there was no room for expansion, and annexation was the only way for the city to grow. On July 1, 1887, the city of Norfolk started a series of annexations that eventually led Norfolk County to merge with the city of South Norfolk to keep from losing all its land. Between 1887 and 1955, the city of Norfolk annexed twenty-three areas from Norfolk County.

Of all the local cities, Chesapeake is the only one whose name actually reflects its deepest roots, and those roots actually lead back to the American Indians. In the early 1600s, when the English settlers began wandering around the Elizabeth River, the Native Americans knew the land as *Chesapeake*, which meant "Mother of Waters." The Chesapeake tribe occupied the land between the Elizabeth River and the Atlantic Ocean. The other tribe nearby was the Nansemond, who roamed the area that is now Suffolk.

The first settlements of what is now Chesapeake got their start along the Elizabeth River in the mid-1600s. Great Bridge, which was a small village, was also one of the early areas to pop up along the Great Road that ran from Norfolk to North Carolina. The trestle that crossed the Elizabeth River became known as the "Great Bridge." In 1775, this bridge would become the scene of a showdown with the British.

In November 1775 the British invaded southeastern Virginia, and on December 9, 1775, Lord Dunmore's troops clashed with the American forces at Great Bridge, just a few yards from where the civic center now stands. After receiving a sound defeat in a battle that lasted less than half an hour, the British retired to the safety of their ships in the harbor at Norfolk.

Introduction

After taking some time to think about the outcome of the battle, and having been refused provisions for his troops by the people of Norfolk, a very angry Dunmore decided to destroy Norfolk. At about 4:00 p.m. on Monday, January 1, 1776, his ships opened fire on the town and British sailors set fire to the wharves. One of the most interesting features of the old Saint Paul Church in Norfolk is the cannonball fired from one of Lord Dunmore's ships in the harbor. It struck the south corner of the church near what was then Church Street. The ball left a large imprint in that corner of the church and then fell to the ground directly below. Eventually, it was covered with dirt and remained buried there until 1848.

The Saturday, May 13, 1848 issue of the *The Daily Southern Argus*, a Norfolk newspaper, reported that a workman digging near that corner of the church found the ball buried about two feet below the surface. The old cannonball was cleaned and then cemented in the wall above where it had originally struck the church. A plate bearing the words, "Fired By Lord Dunmore Jan. 1, 1776," was placed there in 1901 by the Great Bridge Chapter of the Daughters of the American Revolution.

The first guns fired that day in January 1776 were supposedly on the warship *Liverpool*, and many believe that the cannonball that now attracts thousands of tourists each year came from that ship. However, there were several ships in the harbor that day and there was no way to know for sure from which ship it came.

In 1793, work began on the Dismal Swamp Canal. Colonel William Byrd II first proposed its construction when he was in the area in the early eighteenth century, and the proposal was made again by George Washington in 1763. The canal opened in 1805. Another canal linking the Elizabeth River with the Albemarle by way of the North Landing River was dug in the latter 1850s. It had larger locks and deeper water and proved to be a competitor to the Dismal Swamp Canal. This canal became known as the Albemarle and Chesapeake Canal.

In 1801, the Gosport Navy Yard was acquired by the United States government from the Commonwealth of Virginia. The opening of the canal and the government acquisition of the navy yard both provided additional revenue to an already prosperous area.

The first local encounter of the War Between the States was at Sewell's Point in Norfolk in May 1861. Other events of great significance in the area were the burning of the Gosport Navy Yard and the battle between the CSS *Virginia* (*Merrimac*) and the USS *Monitor*. When the war ended there was much rebuilding to be accomplished. Norfolk County had lost a great deal. The wooden schoolhouses had all been torn down and the lumber had been used by the federal forces. The farms were in ruins and the railroads were not operational. But Norfolk County began to take advantage of its natural resources. Its location near the coast, miles of waterfront, deep harbors and fertile farmlands allowed residents to recover from the war and move into the new century.

The city of Chesapeake is composed of numerous small areas. Many of the older residents still refer to the names of the former communities, such as South Norfolk, Portlock, Buell, Great Bridge, Pleasant Grove, Oak Grove, Fentress, Hickory, St. Brides, Deep Creek, Western Branch, Indian River and possibly a few others that have slipped into the past. Where did some of the local names come from?

Probably two of the oldest surviving roads in Chesapeake are Ballahack and Shillelagh. Both were named after colonial plantations that were settled more than 250 years ago by

Introduction

Irish families. Portlock was originally part of a plantation owned by John Portlock, who settled in the area in the latter 1600s. What is now Cedar Road was once known as Poor House Road because the poor farm was located nearby. Later when Richmond Cedar Works was in the area the road was known as Richmond Cedar Works Road. The name was eventually shortened to Cedar Works Road and then to Cedar Road. Many of the other roads were named for the area in which they were located.

Legend has it that Sign Pine Road in the southeastern part of Chesapeake received its name from a sign that was hung on a pine tree. The sign advertised a flour mill that was located along the same route as the tree. Before that the name was Little Green Sea Road, which was supposedly named by Colonel William Byrd II for an area of the Dismal Swamp that was filled with green reeds.

What was Center Green Sea Road is now Johnstown Road. In 1729, the road leading to Norfolk Towne was the Post Road—this later became the Great Road and today it is Battlefield Boulevard. In Deep Creek, Martin Johnson Road was part of a 125-acre farm that was settled by the late Martin Johnson.

In South Norfolk, the name Campostella Road, which runs to the Brambleton area of Norfolk, has been appearing on local maps since the War Between the States. According to legend, a Confederate captain by the name of Fred Wilson organized a soldier's camp on some of his property in what is present-day South Norfolk. He was said to have named the camp in honor of his daughter Stella. The *o* was reportedly added by a real estate agent.

The name Mount Pleasant Road goes back about 150 years. The road was used frequently by Mennonite farmers who settled in the area. Before the Mennonites came, a family known as the Hearings owned a plantation consisting of several thousand acres out that way. One part of the plantation had higher and sandier soil than the rest and became known as Mount Pleasant. Another road that was named in the same fashion after a plantation is Bunch of Walnuts Road. Saint Brides Road was named for Saint Bride's Parish, which had been named after one of Norfolk's early churches. Other roads that are believed to be named for the communities through which they pass—which, in turn, happen to be named for early families that settled in the areas—are Joliff Road and Peoples Road. Land of Promise Road near the Virginia Beach line was most likely named after the Land of Promise community in Virginia Beach.

Several streets located in the Great Bridge Civic Center were named for local patriots and hometown heroes. Let us begin with Polly Miller Circle, named for a Revolutionary heroine who treated many wounded veterans of the Battle of Great Bridge. Shea Drive was named for Army Lieutenant Richard T. Shea, West Point class of 1952, who was awarded the Congressional Medal of Honor posthumously for his service in the Korean War. Shea was an all-American track and field athlete who had been scheduled to participate in the Olympics at Helsinki before the war. Lieutenant Shea had been a farm boy from the Western Branch borough of the city.

Two other streets at the civic center—Holt and Newton Drives—were named for James Holt and Thomas Newton Jr. Both men were members of the House of Burgesses during the 1700s and Newton was a Revolutionary War veteran as well as a signer of the Declaration of Independence.

The new city of Chesapeake divided itself into the following six boroughs: South Norfolk, Washington, Pleasant Grove, Butts Road, Deep Creek and Western Branch. Some people in

INTRODUCTION

our city have no idea in which borough they live. One of my goals in this book is to see if I can be of assistance. I have tried to include some information about each one of them. This has also been a learning experience for me, for I found that some of the boroughs are large in land only, while others are heavily populated with homes as well as businesses.

In addition to information about the six boroughs, the Revolutionary War and the War Between the States, I have included chapters about Jamestown, education and religion in early Norfolk County and a chapter that addresses more recent happenings as well as plans for the future.

Chapter I
The Chesapeake and Jamestown

It was in the year 1585 that Sir Richard Grenville and Ralph Lane ran their boats into that great body of water that the American Indians called *Chesapeake*, meaning "Mother of Waters." They soon found a broad and smoothly flowing river, with low, flat banks densely covered with vegetation of all kinds. The clearings were highlighted with wildflowers of many bright colors. Reeds, ferns, bushes and vines made a beautiful border all the way to the water's edge. The trees, mostly pines, seemed especially tall and stately, and the rushing of the wind through their many branches resulted in a most restful sound found only in pine tree country. Apparently it proved very attractive to the explorers, for they went up the river and its branches as far as they could navigate and into the very heart of what was to become Norfolk County. These men must have carried away with them deep impressions of the beauty, wealth and fertility of the area that they had explored because the following year Sir Walter Raleigh sent out a second expedition with instructions to build a town near the Native American village of Chesapeake, which is near present-day Norfolk, Virginia. This town was to be named for its founder: Raleigh. Possibly due to some misunderstanding, Raleigh's instructions were not carried out. If they had been, Norfolk County would have had an earlier date of settlement and most likely a different name.

Although Sir Walter Raleigh failed to establish a colony in Virginia and the idea was abandoned, others became eager to try again. Large trading companies already existed in other countries. Queen Elizabeth I (1533–1603) chartered the East Indian Company and the organization of this company became the basis for the formation of the London Company of Virginia.

On April 10, 1606, King James I approved the division of this large company into two smaller companies. One became known as the London Company and the other was called the Plymouth Company. It was agreed that the London Company would settle in what became southern Virginia, which received its name from Queen Elizabeth I, the "virgin queen," and that the Plymouth Company would settle in the northern part. Some land would also be open to both companies.

Under the charter of 1606, three small ships—the *Susan Constant*, *Godspeed* and *Discovery*—were equipped, and 104 colonists were sent to Virginia. A council of seven

had been selected to rule the colony and one of the seven was to be president. It would not be known who the members of the council were until the colonists arrived in Virginia, however.

The expedition, under the command of Captain Christopher Newport, sailed from Blackwall in London on December 19, 1606. After a rough voyage, the land of Virginia was sighted about 4:00 a.m. on April 26, 1607. At daylight they passed two capes that were eventually named Charles and Henry in honor of the sons of King James I, and they entered the Bay of Chesupioc (Chesapeake).

The colonists landed at Cape Henry on April 26 and planted a cross, taking possession of the land in the name of the king. They found fair meadows, "goodly tall" trees and fresh water running through the woods. They named the point that gave their ships protection Point Comfort. After several days and several landings, the ships proceeded up a broad river called the Powhatan, or King River. This they named the James River after their king. The site that was selected for the first settlement became known as Jamestown.

On May 14, 1607, the 104 colonists landed and set to work fortifying the area; four months later almost half of them would be dead. Soon after their arrival they learned that Captain Edward Maria Wingfield was president of the council. The other members included Captains George Kendall, John Ratcliff, John Martin, Bartholomew Gosnold, Christopher Newport and John Smith. Smith had been charged with mutiny and could not serve until he was acquitted, which happened without much delay.

Shortly after landing at Jamestown, Captain Newport took twenty-one others up the river in search of a shortcut from the Atlantic Ocean to the Pacific, not realizing how far away the Pacific actually was. But he did find a falls, and above them a Native American town of "twelve houses pleasantly seated on a hill." This was the site of present-day Richmond, Virginia.

The first letter sent back to England from the New World reported the following observations:

> *We are set down eighty miles within a River for breadth, sweetness of water, length navigable up into the country, deep and bold chanell so stored with sturgeon and other sweet fish, as no man's fortune hath ever possessed the like…The soil is most fruitfull, laden with Oake, Ashe, Walnut trees, Poplar, Pine, sweet woods, cedar; and others yet without names that yield gums pleasant as Frankincense and experienced amongst us for great virtue in healing green wounds and aches.*

Crude houses were built, and after the settlers began the construction of log huts, Christopher Newport returned to England. After his departure, John Smith made himself leader of the colonists.

In December 1607 Smith set out to explore the headwaters of the Chickahominy River, when he was captured by a group of Native Americans and carried before Chief Powhatan and then his brother Opechancanough. At that time Smith also met the chief's daughter Pocahontas, "a maid of ten." Pocahontas's real name was Matoaka. There are several stories of how she persuaded her father to release Smith. It was not

The Chesapeake and Jamestown

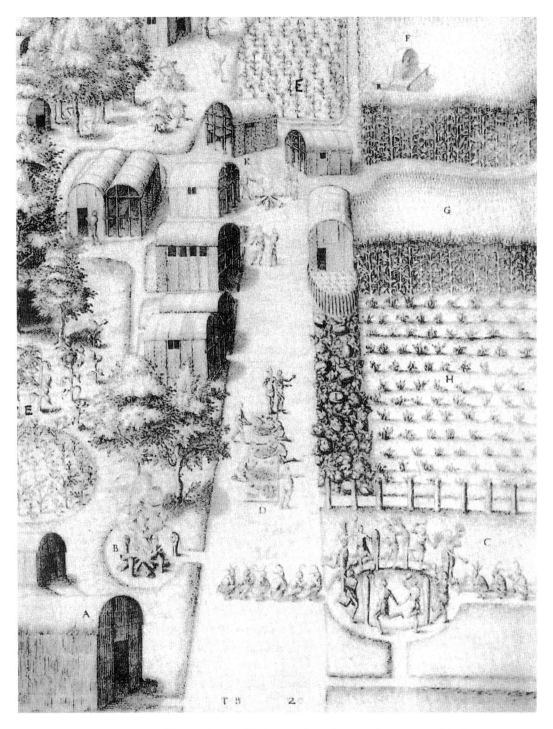

This drawing illustrates how a Chesapeake-area Native American farm may have appeared before the settlement of Jamestown. A tobacco crop can be seen growing, *top center*, and on the *lower left* between the second and third buildings. *From the author's collection.*

until around 1624, several years after Pocahontas's death, that Smith told his version of how she saved his life. In its final form, Smith's story relates that the Native Americans placed his head on two stones and were about to crush it with clubs when Pocahontas threw herself upon him and insisted that his life be spared. However, most historians think it highly unlikely that she did any such thing. Regardless of what happened, Smith was finally released. It was six years later when Pocahontas would really help save the colony—by marrying John Rolfe.

Upon returning to Jamestown, Smith found that many of the settlers had died and others were starving. As luck would have it Christopher Newport arrived soon after with supplies, and the remaining few were saved.

In 1608 Smith set out again to explore the Chesapeake Bay and surrounding areas and drew a map that proved to be very accurate. Due to different languages and dialects, the word Chesapeake was spelled and pronounced in many different ways. Unfortunately, there is no record of the name used by the Native Americans for the bay, but there were several bestowed upon it by early explorers. The first was Bahia de Santa Maria, then Bahia del Xacan. Another early name was Madre Agus, or "Mother of Waters." The bay's present name was taken from the Chesapeake Indians who inhabited the shores of the Elizabeth River, the first inlet inside the capes. The name had many different spellings, including Chesapeach, Chesupioca and Chissapiacke.

The summer of 1608 came, and along with it the colonists were once again feeling the pangs of hunger. Many had died from starvation, some from diseases and others from wounds. The death rate continued to climb. After about five months Christopher Newport again arrived with fresh supplies and the colony was once again saved. In addition to supplies, Newport brought other settlers, one of whom was Anne Burras, who would later wed John Laydon in the colony's first marriage.

In the spring of 1609 some 500 new settlers arrived. About 120 of them settled in what would become Richmond. Problems soon arose between the settlers and the Native Americans and John Smith went on a trip to try to settle the differences. On his return a bag of gunpowder exploded in his boat, injuring him severely, and he was forced to return permanently to England.

The winter of 1609–1610 has been given the name "starving time." It was then that Chief Powhatan and his warriors surrounded the settlement. The colonists soon ran out of food and were forced to eat horses, dogs, cats and even the rats that had made their way aboard the ships from England. To add to their hunger, the drinking water was contaminated. The few that survived were in a weakened state. But the spring of 1610 brought with it additional colonists and supplies.

In 1610, at the age of nine, Thomas Willoughby arrived in Virginia as a passenger on the ship *Prosperous*. As he aged and established a foothold in the New World, his rise was very rapid. He was successively a justice of the peace, a member of the assembly at Jamestown and a member of the Governor's Council. Sometime around 1626 he built his home on that long, narrow peninsula of sand that still bears his name—Willoughby—which is near the Ocean View area of Norfolk, Virginia.

Meanwhile Pocahontas was converted to Christianity and married the colonist John Rolfe, whose first wife had died in a wreck in the Bermuda Islands. The marriage took

place in the church at Jamestown and the couple honeymooned at Rolfe's estate, Varina, on the James River. As Rolfe's wife "Rebecka," Pocahontas visited England in 1616 and was received at the court of King James I. In 1617, while making preparations to return home, she became ill, possibly with tuberculosis, and died at the age of twenty-two, leaving behind her husband and young son. The infant son Thomas had been very sickly and was certainly not well enough to make the Atlantic trip back to Virginia. Because of his condition, when the ship *George* reached Plymouth, England, John Rolfe left the boy in the care of Sir Lewis Stukley. Rolfe never saw his son again.

On March 21, 1617, Pocahontas was buried in the floor of Saint George Church at Gravesend, England. The church burned in 1727 and if there was a carved marker in the floor, its whereabouts is not known.

After returning to Virginia, John Rolfe served as secretary of the colony's governing body. Eventually he married again. This time his bride was Joane Pierce, daughter of William Pierce who had arrived on the ship *Blessing* in 1609. When Rolfe made his will in 1622, he admitted to being in poor health and he died later in the year. His son Thomas, who had been left behind in England, grew up to become a respected Virginia planter and owned two thousand acres across the river from Jamestown. It has been said that Pocahontas had many descendants through her son Thomas Rolfe. Many Virginians claim to be descended from the son of John Rolfe and Pocahontas. It is possible that some are.

Early accounts of the Jamestown settlement made reference to the Chesapeake Indians. William Strachey wrote in his 1612 *History of Travell into Virginia Britania* that Chief Powhatan had exterminated the Chesapeake Indians. John Smith's map placed the village of the Chesapeake in the vicinity of the Elizabeth River.

In 1619, ninety young Englishwomen of unexceptional character arrived at Jamestown. Prospective husbands arranged to pay the cost of the volunteers' outfits and passages with about eighty dollars worth of tobacco. The governor issued a proclamation that maidens who betrothed themselves to more than one lover would be severely punished.

Also in 1619, the first representative governing body met at Jamestown and the first African slaves were brought to the colony aboard Dutch ships.

The colonists' first encounter with the Nansemond tribe was when John Smith's barge was blown into the Nansemond River. He wrote that the Native Americans were friendly at first but then attacked him and his crew. They then retreated and burned the Native American's fields. Supposedly, Smith later talked the Nansemonds into surrendering and giving him many bushels of corn. It seems that he was always getting into some kind of predicament, but only he knew for sure how many of his stories were true.

When Jamestown was settled in 1607, the Nansemond village was located in the general vicinity of Reed's Ferry near Chuckatuck in what is now the city of Suffolk, Virginia. The tribal king lived near Dumpling Island on the Nansemond River about eight miles west of the Western Branch of the Elizabeth River. The population was about twelve hundred, with three hundred bowmen. When the colonists were suffering from a severe shortage of food in 1608, some of the established settlers attempted to start a new colony in the Nansemond territory southeast of Jamestown. This ended in hostilities with the tribe. Today the

Nansemond is the only state-recognized tribe in Chesapeake. It is one of the few remaining tribes of the Powhatan Confederacy.

On November 18, 1618, the Virginia Company's London Council ordered that the Virginia Colony be divided into four large corporations. The next division of Virginia came in 1632–1634, when the colony was split into eight shires or counties. The area from which present-day Chesapeake emerged was successively part of Elizabeth City County in 1634, New Norfolk County in 1636, Lower Norfolk County in 1637 and in 1691 the legislature divided Lower Norfolk County into Norfolk and Princess Anne counties. At that time it was directed that a new courthouse be erected at Norfolk Town and that it become the county seat. The Lower Norfolk County Courthouse, which had been built in 1661, had served as Norfolk County's first courthouse. Work on the new courthouse was begun in the summer of 1691 and was completed in 1694. Its location was on the north side of Norfolk's Main Street. In 1789, the Virginia legislature chose Powder Point, now called Berkley, as the location for the next Norfolk County Courthouse. After twelve years it was moved to Portsmouth where it remained until Norfolk County merged with the city of South Norfolk in 1963. At that time all of the records were moved to the office of the clerk of the circuit court in the city of Chesapeake, Virginia.

The Native Americans grew corn, squash and beans. In spring and until the arrival of the early harvest of corn, they relied on fish, which they caught using spears and nets. The waters were plentiful with fish, especially the big, meaty Atlantic sturgeon. This would lead one to question whether the colonists actually died mainly from starvation, especially during the summer months when the fish were most plentiful. It is more than likely that the majority of them died from diseases such as typhoid and dysentery caused by contaminated well water and salt poisoning from the ocean water.

However, as the English moved into the lands around the Chesapeake Bay, the Native Americans in the region resented seeing their land occupied by the white men. Powhatan was sometimes hostile to the settlers, but in the beginning he was no match for John Smith, and later the English continued to come in larger numbers. After his daughter Pocahontas married John Rolfe, Powhatan lightened up and yielded to most of the English demands. When he died in 1618, his brother Opechancanough became his successor and continued to maintain peace with the English until an incident took place in which "Jack of the Feather," a stalwart Indian, killed an Englishman by the name of Morgan. Two of Morgan's servants charged him with murdering their master and proceeded to wound him fatally. In retaliation, on Good Friday morning in 1622, the native tribes attacked the settlers. Altogether, 347 persons were killed. This was a severe blow to the colony, but in about eight months it recovered and actually became stronger than before.

On October 21, 1698, the fourth statehouse burned. It was then that Jamestown ceased to be of political importance. The following year the colony's administration moved to Williamsburg, where it remained through the rest of the colonial period. The next move would be to Richmond.

The year 2007 marked the four-hundredth anniversary of the arrival of the English at Jamestown. Upon their arrival in 1607, more than fifteen thousand Native Americans

The Chesapeake and Jamestown

This was a Native American house at Jamestown. *From the author's collection.*

lived in the vicinity of the Chesapeake Bay. Most of them were under the control of Chief Powhatan. Within sixty years the settlers had forced the native tribes off the most fertile lands and only two thousand Native Americans remained.

Chapter II
The War for Independence

The colonists continued to live rather monotonously, at times fighting the Native Americans. Powhatan, who was probably in his late eighties, died in April 1618 and was succeeded by Opechancanough. On April 18, 1644, when he was about ninety years of age and in poor health, Opechancanough decided to make one last attempt to obliterate the colonists. This attack was more successful than the one he pulled off in 1622 in that more than five hundred of the colonists were killed. However, its impact was not as great because the population in 1644 was much larger than it had been in 1622.

Opechancanough was captured and imprisoned at Jamestown, where he died at the hands of a soldier who shot the old man in the back. With both him and Powhatan gone, the English were able to breathe a little easier while accomplishing their daily chores and attending worship services. The number of settlers continued to increase. When the fourth statehouse burned on October 21, 1698, a decision was made to move the colony's administration to Middle Plantation, which was renamed Williamsburg in 1699.

When the colonists realized that there was likely to be a struggle with England, they immediately began enlisting minutemen and drilling them into some sort of military discipline. Each county was asked to furnish an equal percentage of their male population. Trouble had been brewing for some time under the rule of John Murray, the Fourth Earl of Dunmore and the royal governor.

Many events led up to the American Revolution. New taxes were imposed on the colonies and the spirit of resistance grew intense. In 1775, Dunmore broke off communications with the Virginia Assembly. On April 20, he removed the gunpowder from the public magazine in Williamsburg, the capital at the time. He began to fear for his safety and took refuge with the British Fleet in the York River. By July 1775 these ships had moved to the Elizabeth River near Norfolk, where they were soon strengthened by the arrival of additional warships. This location was where Dunmore planned to make his headquarters. With the fleet anchored offshore, he was certain that he could retake the colony.

On September 30, 1775, Dunmore sent his troops to Norfolk to destroy the printing press of James Holt and with it the freedom of speech that had belonged to the people. When this took place, the anger of the colonists could no longer be restrained. Lord Dunmore and the people of Virginia were now at the point of warfare. The minutemen of the upper counties were concentrating at Williamsburg, where they were making plans for a march on Norfolk. The Revolutionaries of Norfolk and Princess Anne, under the leadership of Colonel Matthew Phripp of the Norfolk militia, Colonel Arthur Lawson and others, assembled and posted themselves at Kemp's Landing and other strategic points. Most of the patriots in Norfolk had already left to join the militia, and there was an exodus along Church Street and the road leading to Great Bridge. On November 7, Dunmore issued a proclamation declaring martial law.

With a reinforcement of sixty men from Saint Augustine, Florida, Dunmore was able to muster two hundred soldiers and a few Tories for a descent on Great Bridge. The Town of Great Bridge was approximately ten miles from Norfolk Town along the Post Road and at the head of the canal on the Southern Branch of the Elizabeth River. This community had been established on January 29, 1729, and its trustees included Samuel Willis, John Caldwell, William Grimes Sr., John Jones, John Hodges Jr. and Edward Hall Sr. Some years later the town retrograded to a village.

The community of Great Bridge received its name from a 40-yard wooden bridge that crossed a marshy area on the Southern Branch of the Elizabeth River in the 1700s. There was marshy land extending approximately 150 yards on either side of the bridge. From the northern end of the bridge there was a long causeway crossing the marsh to an island of firm earth. There was a similar causeway and island at the southern end of the bridge. This island in turn was connected with the Village of Great Bridge by another causeway. This network of causeways along with the bridge made up the only crossing over the Southern Branch on the route from North Carolina to Norfolk. Great Bridge, at that time, was at the intersection of two roads from North Carolina and was a transfer point for tobacco, lumber, grain, pitch, tar and turpentine. Because of its location, it was chosen as the site for one of the largest tobacco warehouses in the state. On the southern island were a number of warehouses, where goods were taken on and off riverboats. The British put up a stockade fort on the northern island and planted guns there.

Finding no militia at Great Bridge and learning that Colonel Lawson was at Kemps Landing, Dunmore marched there and won an easy victory. Several men were killed, two drowned in their flight and fourteen were taken prisoner. On November 16, Dunmore marched into Norfolk. There he found Scotch merchants and their clerks, and he forced their allegiance to the crown of England. He then made plans for fortification of the town and began construction of earthworks. This was one of many mistakes that he would make, for Norfolk's real strength against attack by land lay in the routes leading to the area.

Dunmore learned all too soon of his mistakes in fortifying Norfolk. If the British had erected works at Bachelor's Mill on the edge of the Dismal Swamp and at Great Bridge, the Virginians would probably never have gotten near the Village of Great Bridge. The forty-yard bridge, together with its surroundings, was a place of natural strength.

The War for Independence

Meanwhile, the Virginians under the command of Colonel William Woodford, along with Lieutenant Colonel Scott and Major Thomas Marshall, had left Williamsburg, crossed the James River and headed for Suffolk where there were large numbers of stores and provisions. Major Marshall, who was later promoted to colonel, was the father of John Marshall. In 1775 John Marshall was a twenty-year-old militiaman, and the following year he joined the Continental army. One of President John Adam's last acts in office was the appointment of John Marshall as chief justice of the U.S. Supreme Court.

When Woodford's forces reached Great Bridge, they threw up breastworks across the southern end of the causeway, which they manned with a few men. The main force was posted in the village behind it. There they remained for several days, awaiting reinforcements from North Carolina under Colonel Robert Howe. Woodford could not have forced his way over the Southern Branch, and to charge across the causeway and bridge against the British would have been very costly. To flank the position on the right was not possible because of the marsh, and on the left, the British sloops guarded the river. Eventually, the enemy took the initiative. A slave belonging to Major Marshall faked desertion to the British and informed Dunmore that the Virginians numbered no more than three hundred. Remembering how the militia had fled at Kemp's Landing, and thinking these men to be of the same caliber, Dunmore decided to attack.

The Battle of Great Bridge

The royal governor assembled all his available regulars, sixty Tories and some sailors from the warships, and this force, along with thirty whites and ninety slaves already there, brought the total up to several hundred men. On the morning of December 9, 1775, the Virginians heard reveille in the British fort that was followed by the blast of cannons and muskets. The British regulars appeared first and were followed by the Tories and slaves. The foremost ranks carried planks, which were used to cover the broken part of the bridge. This permitted the troops and two cannons to cross to the south island. After burning a few houses and piles of shingles, they opened fire on the American breastwork. The British regulars under the command of Captain Charles Fordyce then advanced over the south causeway. The Americans, behind their breastworks, waited. Lieutenant Edward Travis ordered them to hold their fire until the enemy was within fifty yards. Then, when given the signal, they opened fire. Some of the British forward troops were killed, others were wounded and the back ranks began to falter. Captain Fordyce waved them on, but as he approached the breastworks, he fell mortally wounded. It was reported that he had fourteen wounds in his body.

British Captain Samuel Leslie tried to rally the troops. The Tories and those in the rear had not advanced beyond the island and two cannons continued to play upon the Virginians. At this point in the battle, Colonel Woodford brought up reinforcements, opened fire and forced the British to retreat across the bridge. As the firing ceased, some of the Virginians climbed over the breastworks to assist the British wounded. Captain Leslie reportedly stepped out in front of the fort and bowed his thanks for the consideration shown by the American troops. On the evening of the battle, the British retreated. With all that took place

A History of Chesapeake, Virginia

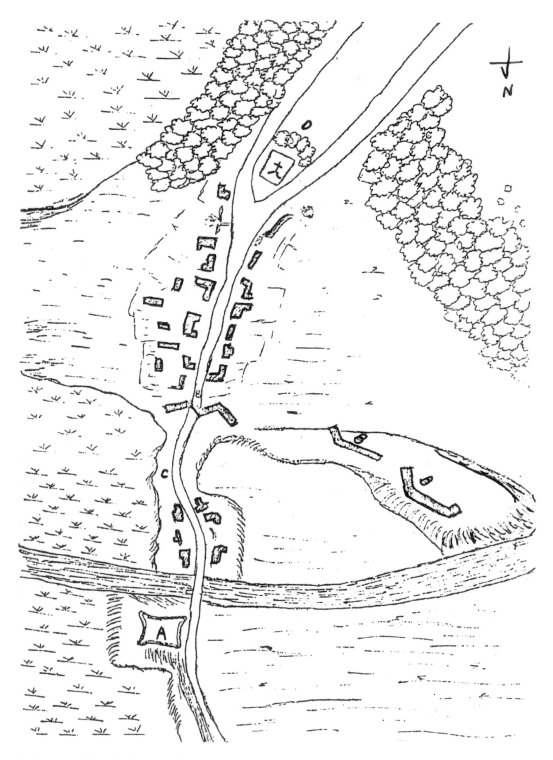

In this map of Great Bridge from the time of the battle, *A* is the fort built by Lord Dunmore's troops, *B* indicates the fortifications built by the Americans and *C* is the causeway across the swamp. The Great Bridge itself is directly in front of the British fort, crossing the Southern Branch of the Elizabeth River. *From the author's collection.*

The War for Independence

that day, it was reported that the British lost at least forty men, and the single injury in the American ranks was a slight wound to the hand of one soldier. The actual battle lasted no more than thirty minutes.

Fearing that he could not hold Norfolk, Dunmore retired to his gunboats in the harbor. Afterwards, he sent ashore under a flag of truce for provisions, and when his request was refused, he went into a rage and was determined to destroy the town of Norfolk. He sent a warning that the women and children should be taken out of harm's way. At about 4:00 p.m. on New Year's Day 1776 the boats started up a heavy cannonade and parties of sailors under this protection managed to set fire to the wharves and practically burn the entire town. Old Saint Paul's Church on Church Street (now Saint Paul Boulevard) was about the only building of importance that escaped the flames. A cannonball, however, hit one of the walls of the church and dropped to the ground, where it became covered with dirt and was not discovered until 1848. In 1901 the cannonball was cemented into the wall where it originally struck the building, and a plate of identification was installed.

Between July and October 1777, the following oath of allegiance was passed among the colonists:

> *I do swear or affirm that I renounce and refuse all allegiance to George III, King of Great Britain, his heirs and successors and that I will be faithful and bear true allegiance to the Commonwealth of Virginia as a free and independent State, and that I will not, at anytime do or cause to be done any matter or thing that will be prejudicial or injurious to the freedom and independence there of as declared by congress and also that I will discover and make known to some one Justice of the Peace for the said State all treasons or traitorous conspiracies which I now or hereafter shall know to be formed against this or any of the United States of America.*

This petition was first dated and signed by Cornelius Calvert and John Wilson on July 18, 1777. The final page stated, "*To the oath or affirmation of allegiance to this Commonwealth before me given under my hand and seal this 17th Day of October 1777.*" Matthew Godfrey also signed it, and he then listed the names of three persons who refused to sign the oath.

For the immediate future, there was nothing more of special interest until 1779, when the English, under General Edward Matthews, landed in Portsmouth and made it their headquarters. The British captured a large number of vessels, which were at that time on the Gosport anchorage, and forced the garrison to leave Fort Nelson, which was built on the present site of the Naval Hospital at Portsmouth, Virginia. A few months later, General Alexander Leslie added three thousand troops to Matthews's forces, and together they ruined a large amount of property across Tidewater, Virginia. The next year the notorious American traitor Benedict Arnold held the town with orders to do as much damage as possible, to spare nobody and to leave nothing.

Late in the war the British, in great numbers, returned to Virginia and Great Bridge was once again fortified. A leading Loyalist unit known as "the Queen's Rangers," under the command of John Graves Simcoe, was stationed at a newly established location; however, the British had apparently learned an important lesson in 1775 and there was not another

battle at Great Bridge. After having served the Crown as one of its brightest commanding officers, Simcoe was appointed the first lieutenant governor of Upper Canada. The Revolutionary War continued until Lord Cornwallis went to his final and conclusive defeat at Yorktown in 1784. The Queen's Rangers inflicted no damage because they were poorly equipped—many even without shoes.

Lord Cornwallis was hemmed in at Yorktown and forced to surrender in October 1781. Among the colonists present at the surrender were George Washington, Nathaniel Greene and Henry Knox. Although the war had ended, peace terms were not concluded between England and its former colonies for two more years. The devastation in Norfolk, Portsmouth and vicinity was more complete than in most other areas. Some parts were described as nothing more than piles of trash and heaps of pure rubbish; however, by 1779 Reconstruction had begun to take place and things were looking up. Norfolk County had experienced some damage to buildings and fields. The farmers began gradually clearing the land and the crops came back larger than before. Today those fields are an integral part of the city of Chesapeake, Virginia.

Chapter III

The War Between the States

In the year 1861 the city of Portsmouth, which was the seat of Norfolk County, had a population of about nine thousand persons. The population of Norfolk County was approximately twelve thousand. The Gosport Navy Yard, the largest of its kind in the United States, was located on the southern end of the city and usually employed twelve hundred to fifteen hundred workers. The city for the most part was prosperous and content.

On February 4, 1861, the people were faced with the question of whether to secede from the Union in the form of an election for delegates to the state convention. The two representatives running on the Union ticket won, by a large majority, over those who ran on the Secession ticket. Union sentiment predominated in the state convention. Also in February, a secessionist congress had convened in Montgomery, Alabama, and declared a provisional government, voting Jefferson Davis president of the Confederate States of America.

Several Southern states had already seceded from the Union by this time, and instead of trying to persuade them to return, the men who controlled the new Republican-influenced administration were in favor of forcing them back into the Union. President Abraham Lincoln, who had taken office on March 4, 1861, later issued a call for seventy-five thousand troops, and he assigned Virginia its share in response to the violent takeover of Fort Sumter in South Carolina. It became evident that Virginia could not remain neutral but would have to fight with or against the other Southern states. The state convention passed the ordinance of secession on April 17, 1861, and the resolution was to be submitted to the people for vote on the fourth Thursday of May, but for all intents and purposes, the state was out of the Union after the convention.

In the spring of 1861, the U.S. Army was a small organization of sixteen thousand regulars, most of whom were scattered along the Western frontier. Of this number there were approximately eleven hundred officers and more than three hundred of them had resigned their commissions and sided with the South.

The U.S. Navy was in the same shape. About half the fleet, including its most powerful steam frigates were out of commission, obsolete and unfit for service. Personnel

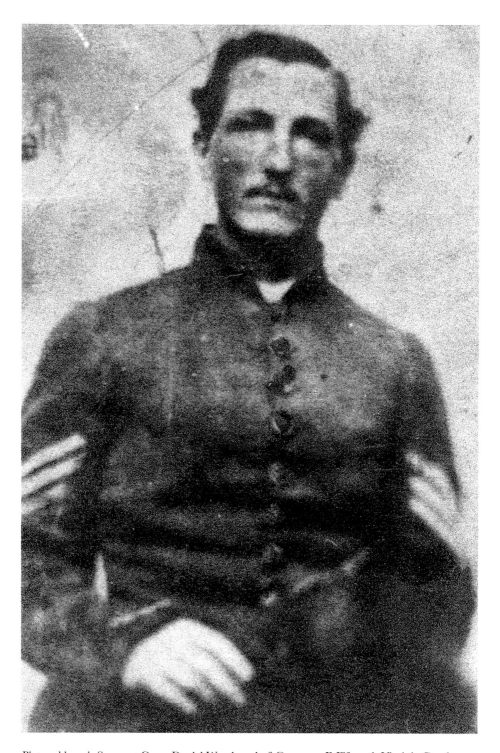

Pictured here is Sergeant Carey Daniel Woodward of Company F, Fifteenth Virginia Cavalry. Members of Company F belonged mostly to Saint Brides Parish of Norfolk County. After the war, Woodward spent most of the rest of his life farming, but he also served as a constable in Norfolk County. *Photo courtesy of Stuart Smith.*

The War Between the States

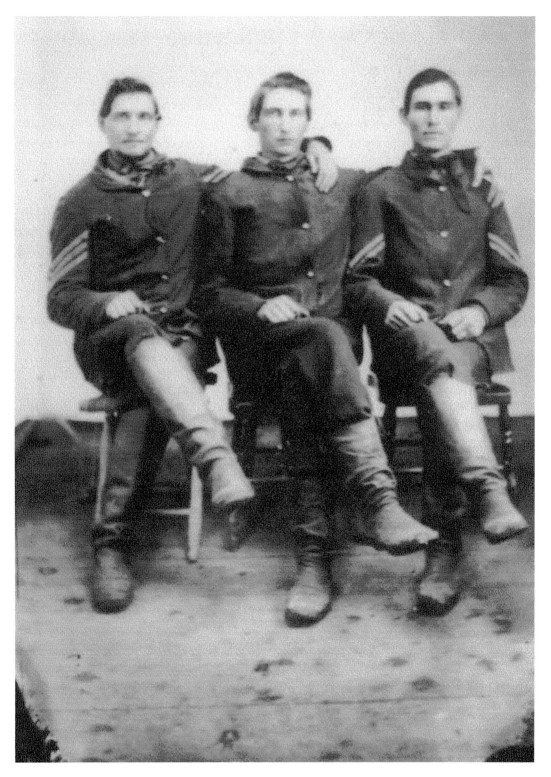

This picture of Daniel, Adam and James, the Alt brothers from Springfield, Ohio, was taken circa 1861. *Photo courtesy of Sue Loonam.*

consisted of 1,457 line and staff officers, 7,600 enlisted men and about 1,400 marines. Some 250 officers submitted their resignations to join the Confederacy. Secretary of the Navy Gideon Welles chose not to accept them, but instead decided to dismiss these men from the naval service.

The navy yards were full of corruption. Most civilian workers received their jobs on the basis of party affiliation and were assessed contributions by the district congressmen. Usually when a new president came into office, those who favored the new administration replaced the workers. President Lincoln chose not to do this. This proved to be an error in judgment because the nearly one thousand civilian workers at the Gosport yard remained Democratic in politics and Southern in sympathy.

The Gosport Navy Yard, which was about three-quarters of a mile long, was actually located across the Elizabeth River from the city of Norfolk. In 1861, it was under the command of Commodore Charles S. McCauley, who was as antiquated as the ships. He had served the U.S. Navy for fifty-two of his sixty-eight years. McCauley had entered the navy as a midshipman in 1809 and served on a frigate during the War of 1812. At his command were only sixteen officers, fewer than a hundred sailors and sixty marines. Most of the officers were loyal to the South.

The yard was completely equipped for building the largest and most modern warships, and five steam vessels had already been launched from there. The yard's most valuable asset was its new granite masonry dry dock. One of only two in the nation, it could berth any vessel in the fleet at that time. Across the Elizabeth River from the yard were the powder magazine at Fort Norfolk and the gun carriage at Saint Helena. Neither was guarded.

McCauley was uncertain as to what course of action to take, for he had received no instructions from the navy department. His last orders, which were received April 16, ordered him to outfit the *Merrimac* and to send her with other vessels capable of being moved, together with ordnance and stores, out of reach of potential danger. The commodore thought the order from the navy department was to abandon the navy yard and not to fire on the city of Portsmouth. In light of the last orders he had received from Washington, McCauley was determined to leave with what he could take and destroy the rest.

The continuous movement of trains on the Norfolk and Petersburg Railroad within hearing distance of the navy yard led McCauley to believe that there had been a large influx of troops into the area. General William Mahone, who was then president of the railroad, instigated the noise for the purpose of creating just such an impression.

Destruction of the yard began about noon on April 20, and the frigate *Merrimac* was the first object of those assigned to the destruction detail. The bilge cocks of the *Merrimac* were opened, and she filled with water and settled to the bottom. After the twelve o'clock bell was rung for the workers to break for lunch, the gates of the navy yard were closed and no one was permitted to enter without the approval of the commodore. The work of destruction then proceeded very quickly. The *Germantown, Plymouth, Dolphin, Delaware* and *Columbus* were scuttled. In late afternoon, the sloop of war *Pawnee,* under Captain Hiram Paulding, docked at the navy yard, and her crew was added to the wrecking force. Captain Pauling gave the order to torch the buildings. Several were filled with stores, which were also destroyed.

The War Between the States

One of the buildings contained large amounts of liquor, and the sailors filled themselves until they were too drunk to continue the work of destruction. Captain Pauling was later promoted to the rank of commodore and was the navy's senior line officer.

It was reported also that there was an attempt to blow up the large stone dry dock, and when the Portsmouth military companies marched into the navy yard the next day, they found loose gunpowder all over the dry dock. The cause of the failure to ignite the powder remained a mystery until February of the next year. The man in charge of the detail lit the fuse, but instead of lighting the powder, he threw the fuse overboard. The reason he gave for doing this was that he had a number of friends in Portsmouth and the amount of powder used would have blown some of the stone beyond the navy yard and could have killed someone.

It did not take the Confederates long to get the navy yard back into operation. The salvage and repair was accomplished under the new commandant, Flag Officer French Forrest. The most noteworthy achievement of all was the conversion of the *Merrimac* into the ironclad CSS *Virginia*. On May 30, Forrest wrote to Robert E. Lee, "We have the *Merrimac* up and just putting her in dry dock."

On March 8, 1862, this transformed frigate sank the *Cumberland* and captured the frigate *Congress*. The next day she met the *Monitor*—the Federal prototype ironclad vessel—and the historic battle of the ironclads took place. This was the most notable event of the war within the bounds of Norfolk County. The outcome of the battle seems to have depended largely on the point of view of the witness. While one claimed that "the *Monitor* was the first to get enough and retired behind the *Minnesota*," most historians contend that the battle was a draw as the *Monitor* had succeeded in protecting other Federal vessels. Later in the war the CSS *Virginia* was run ashore, dismantled and burned by her crew to prevent capture by Federal forces occupying the area.

The people of Norfolk County suffered through four years of destruction. Farms were destroyed, livestock and crops were stolen and most of the wooden schools were dismantled or burned. When the war ended, Virginia faced the monumental task of reconstruction. The state's industrial base had been destroyed, the railroads were in ruins and the agrarian economy was devastated. Many thousands of Virginians were surviving only on the rations distributed by the Union army. Thousands of returning soldiers and others were without employment or a place to live. In addition, more than thirty thousand Virginians had died during the war.

On May 9, 1865, President Andrew Johnson recognized Francis H. Pierpont as provisional governor of Virginia. The government originally was based in Alexandria, but Pierpont soon moved his administration to Richmond, where he hoped to restore his state to its former status in the union.

In October 1865 a full government was elected along with congressional representatives. The acceptance of the representatives would have rendered restoration complete but Congress refused to seat them. The presidential plan of reconstruction was rejected and Congress undertook the work itself. Early in December 1865 the legislature convened in Richmond, enacted vagrant and contract laws, wiped out of the statute books all laws relating to slavery and placed blacks on the same footing as whites, with the exception that they could not vote or hold office.

A History of Chesapeake, Virginia

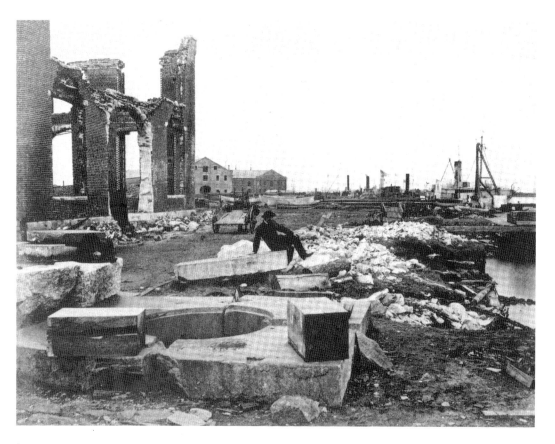

Pictured here are the ruins of the Norfolk Navy Yard in December 1864. The yard is across the Elizabeth River from present-day Chesapeake and can be easily reached by crossing the Jordan Bridge in South Norfolk. *From the author's collection.*

The congressional Reconstruction Acts were passed in March 1867 and the state became Military District Number One. The Acts gave the blacks the vote. About one year after the close of the war the relationship between whites and blacks was reportedly cordial.

Prosperity returned to the Norfolk area when the railroads began bringing coal and produce from the west and points south. Railroads were a boon to Norfolk and also to the farms and villages of Norfolk County. New industries grew up along the Eastern and Southern Branches of the Elizabeth River and new businesses and housing appeared near the railroad line.

When the war started, the boys and young men of what is now Chesapeake had dreams of military glory. Little did they realize that it would be a long and bloody war with a very high number of casualties. One survivor from the area was William Henry Stewart, who early on met with a group of friends at Pleasant Grove Baptist Church and organized what became known as the Jackson Grays. Stewart was elected captain and William Wallace was first lieutenant. Wallace eventually became captain of the Grays and Stewart finished the war as a lieutenant colonel in the Confederate army.

The War Between the States

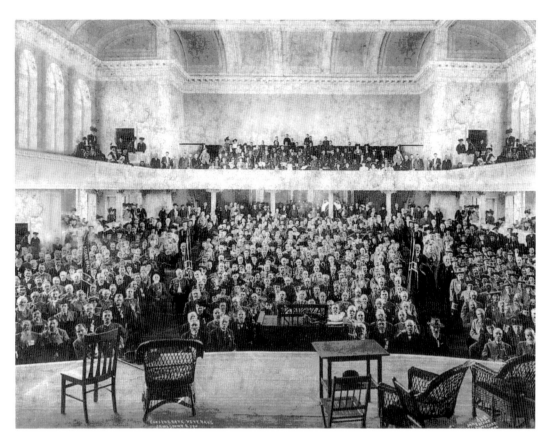

This large gathering of Confederate veterans met at the Jamestown Exposition on October 25, 1907. *Photo courtesy of Stuart Smith.*

Chapter IV

Local Education

The school system in the city of Chesapeake is one of the finest in the country. It dates back to colonial times and continues to thrive well into the twenty-first century. How did it all begin? Historians tell us that Virginians have been interested in education since early in the seventeenth century. Many of our first citizens had been educated in England; however, in the colonies it was difficult to provide schooling for the children. Large distances separated families and travel was mostly by boat, making it virtually impossible to establish schools that could serve all the youth.

Because of the many obstacles involved, education became a family responsibility. The typical school of colonial Virginia was conducted by a member of the clergy or by a private tutor hired by the families, most of whom were planters. The children at these schools were the planters' children and sometimes the children of their nearest neighbors.

Later in the seventeenth century, parochial and private schools opened for the affluent class and arrangements began to be made for educating the poor. In 1642, Benjamin Symes gave land for the purpose of establishing a free school and encouraged others to do likewise. The will of Richard Russell, which was probated December 2, 1667, set aside a portion of his estate to be used to educate six of the poorest children in Norfolk County, and in 1691, Captain Hugh Campbell donated land and tobacco for the "employment of suitable persons to give instruction to the people living along the Northwest River in Norfolk County."

Throughout the seventeenth and eighteenth centuries there were several parochial and private schools in the towns of Norfolk and Portsmouth, and in the county at Hickory Ground, Great Bridge and Sycamore Hill. It was not until the beginning of the nineteenth century that the corporate authority of the county or state entered into any organized system of free public education.

In 1799, schools were opened in several localities of Norfolk County for free instruction of children for three years. One was located at Hickory Ground, a community in the southeastern section of the county along the Great Road (now known as Battlefield Boulevard) on which was located the Great Bridge. In 1835, the old frame or log building

was replaced by a brick structure, incorporated by the General Assembly of Virginia and given the name Saint Brides Academy. Another school was located in the northwest section of the community that was later known as Churchland. In 1802, it was known as the Craney Island School, and in 1840, when it was rebuilt, it became known as the Sycamore Hill School.

In 1845, Norfolk County put into operation a complete system of public schools for the benefit of all free white children of the county. By authority of an act by the General Assembly of Virginia, enacted February 17, 1845, a board of school commissioners met at Deep Creek. They organized and elected Leroy G. Edwards, chairman; George T. Wallace, clerk; and Stephen B. Tatem, treasurer. The commissioners arranged for the opening of twenty schools with three local trustees for each school. The trustees were instructed to provide a building and employ a teacher for a term of ten months at a salary of thirty dollars per month to be paid out of public funds. Between 1845 and 1861 the number of schools grew to thirty.

The first teacher's institute was organized in 1845 when three teachers met at Deep Creek. The name given to the organization was the Seaboard Teacher's Association. Professor N.B. Webster was elected president.

This superb system of thirty schools, which had been open for ten months per year for sixteen years and had accomplished so much for the county, suddenly came to an end. In the spring of 1862, the Union army took possession of the local cities and the county of Norfolk. The schools were closed and the buildings were destroyed. Some were burned; others were torn down by the Federal soldiers and the timbers were moved to military camps where they were used to build winter quarters for the troops. Among the schools destroyed were those at Wallaceton, Cornland, Good Hope, Bell Mill and Tanner's Creek.

In December 1869 Governor Gilbert C. Walker commissioned Captain John T. West as superintendent of schools for Norfolk County. Captain West wrote in his journal, "Received notice of my appointment to the office of Co. Supt. Of schools in December 1869 and entered upon the discharge of duties of the office January 1, 1870." His instructions were to recommend to the state board of education three men from each magisterial district of the county to form a county school board. The following gentlemen were recommended and were appointed trustees by the state board of education:

District No. 1 Western Branch
John T. Griffin, D.T. Driver and W.J. Nicholson.
District No. 2 Deep Creek
Captain Thomas M. Hodges, Willis W. Tucker and John F. Carr.
District No. 3 Pleasant Grove
William R. Dudley, C.T. Forehand and E.H. Williams.
District No. 4 Butts Road
Harrison Etheridge, Griffin Jennings and Jesse D. Sykes.
District No. 5 Washington
Major William H. Etheridge, Milton Cutherell and Henry Butt.
District No. 6 Tanners Creek
Washington T. Capps, Joseph R. Guy and James Sammons.

Local Education

On January 20, 1871, the trustees met at the courthouse in Portsmouth and organized the Norfolk County School Board with Superintendent John T. West as chairman and Captain Thomas M. Hodges as clerk.

Superintendent West served three terms. In 1882, he was succeeded by Jesse E. Baker, who served four years, after which Captain West was again elected to the position and served until 1908 when he retired with thirty-five years of service. When West retired, his last report showed seventy-six buildings fully equipped with patent desk, slate blackboards, maps, globes, chairs, et cetera. These were valued at sixty-five thousand dollars and two eight-room buildings under construction were each valued at fifteen thousand dollars.

The establishment of high schools in Norfolk County began to receive support from the citizens, and in 1906 plans were made for a high school to be located in the small village of South Norfolk. The following year a high school was erected in the Great Bridge area.

The schools of Norfolk County continued to progress, and by 1907 there were 168 schools with an enrollment of 84,000 students. The average school year was nine months, and the maximum teacher salary was $110 per month.

During World Wars I and II many families came to the area seeking employment in the defense industry. Housing was needed, and the federal government built communities as well as schools to accommodate the influx of new residents.

After the war emergencies many people left the area and some of the temporary housing was removed; however, the existing schools were still overcrowded. To add to

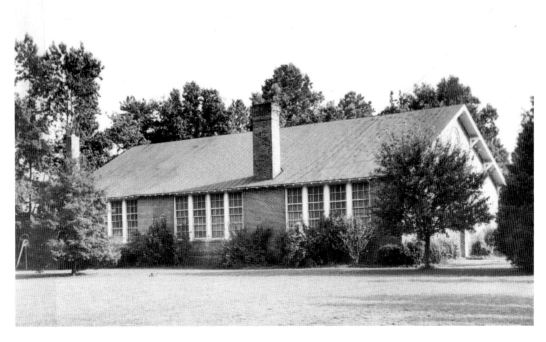

The Sunray School was built on Homestead Road in 1922. Later the building was used as a post office. The community of Sunray was founded in the latter 1800s by a group of Polish Americans. *From the author's collection.*

A History of Chesapeake, Virginia

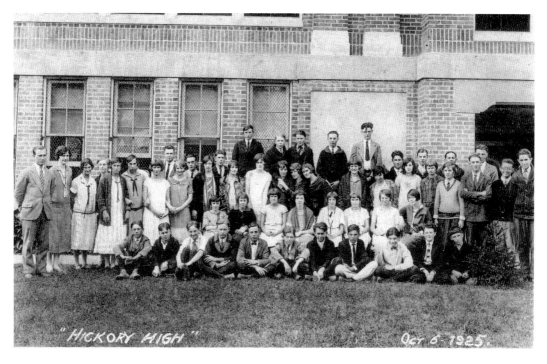

On October 6, 1925, a group of Hickory High School students posed for this class picture. *Photo by Long's Studio, Norfolk, Virginia. From the author's collection.*

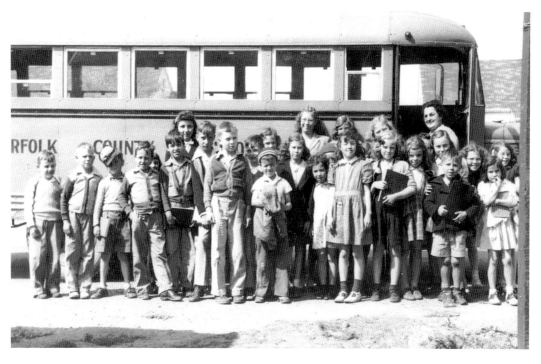

This group of Norfolk Highland schoolchildren and Mrs. Traci Fulford, driver of the bus, posed for this picture in front of Steven's Store in the spring of 1947. This was Mrs. Fulford's first year as a Norfolk County school bus driver. *Photo courtesy of Mr. Ernest Fulford.*

Local Education

this problem, in 1946, transition from an eleven- to twelve-year school system began to take place. New schools were needed, and in 1950 a four-million-dollar bond referendum received a favorable vote from the citizens. In 1960, another bond program for six million dollars was approved.

On January 1, 1963, Norfolk County ceased to exist. It was on that date that the city of South Norfolk and Norfolk County merged to form the city of Chesapeake. The Norfolk County school system at that time was under the direction of E.W. Chittum, and the South Norfolk schools were led by E.E. Brickell. When the school boards combined, Chittum became the first superintendent of Chesapeake Public Schools.

Later that year Chesapeake opened the first planetarium in Virginia to be operated by a school system. Oscar F. Smith High School, which was part of the South Norfolk school system before the merger, was operating the state's first high school FM radio station, WFOS. Smith High also operated an elaborate in-school closed circuit television system, which was very advanced at that time. It would be the forerunner of a cable TV station placed into operation by the school system in 1986.

Since that time many new schools have been built throughout the city of Chesapeake. The new Grassfield High School opened in the fall of 2007 and work has begun on the construction

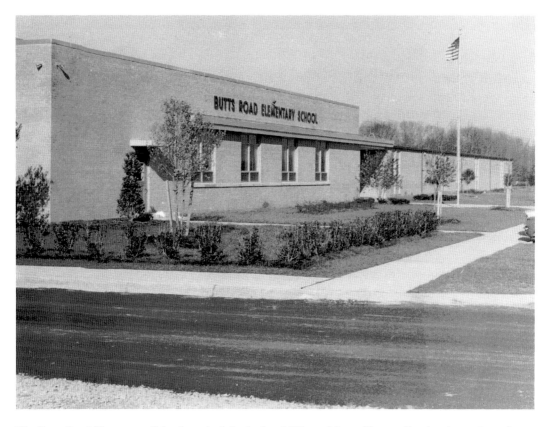

The Butts Road Elementary School was built in the late 1960s on Mount Pleasant Road and served mostly a rural population until the Great Bridge building boom of the 1980s. Eventually another elementary school was built down the road. *From the author's collection.*

of the new Oscar F. Smith Middle School on Rodgers Street in the South Norfolk borough. Groundbreaking ceremonies were held on Thursday, September 13, 2007, at 4:00 p.m.

Superintendents of Norfolk County/Chesapeake Schools

Reverend Thomas Hume	1849–1851
Leroy G. Edwards	1852–1862
John T. West	1870–1881
Jesse E. Baker	1882–1885
John T. West	1886–1908
A.H. Foreman	1908–1916
James Hurst	1917–1942
Henry I. Willet Sr.	1942–1945*
William A. Early	1946–1948
Edwin W. Chittum	1949–1975
Kenneth Fulp	1976–1980
C. Fred Bateman	1981–1995
W. Randolph Nichols	1995–present

*Mr. Willet replaced Mr. Hurst, who died October 5, 1942.

History and Development of South Norfolk Schools

The story of the South Norfolk schools begins with a little one-room building known as the Providence School. It was established around 1872 at the junction of Providence and Campostella Roads.

The next public school for white students was at Money Point. Classes were held in a church until the school in Portlock was completed around 1895. The school was a one-room frame building. The history of the Rosemont Church mentions using the school building to hold prayer meetings in 1902. When the one-room structure was completed, Miss Rena B. Wright, the teacher at Money Point, moved with her students to the school in Portlock. Miss Wright taught at this school for two or three years. For a while, the school at Portlock continued to be known as the Money Point School.

On August 31, 1895, School District Number Five of Norfolk County acquired a parcel of land in Washington Magisterial District from the Shea family for the sum of $150. By 1908 a four-room brick school building had been erected on the property. The structure still stands at 3815 Bainbridge Boulevard in the Portlock section of the city.

A public school was organized in South Norfolk as early as August 1891. Forming an organization called the South Norfolk School Society, a group of men in the community erected a two-room wooden school building on property acquired from Mr. E.M. Tilley. The school was built on Jackson Street in what is now the 1100 block between Guerriere and Ohio Streets. The cost, including furniture and outbuildings, was approximately $2,200. The teachers were Miss Annie Gammon and Miss Lucy Scott. Captain John T. West was

Local Education

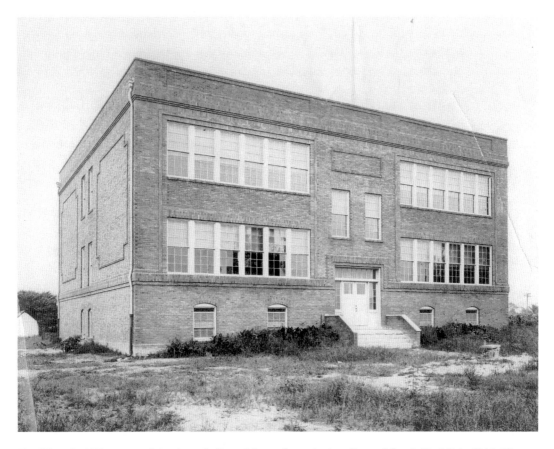

The Waterford Elementary School was built on Liberty Street in the village of South Norfolk in 1913. The school and grounds covered 1.3 acres and had the capacity for 510 students. Later the name was changed to the Edward Williams School. *Photo by H.C. Mann. From the Author's collection.*

superintendent of Norfolk County schools at that time. South Norfolk was a part of Norfolk County until September 1919. An increase in enrollment soon required the addition of a third room. Miss Grace Coggins was principal at that time. When she married, Miss Rena B. Wright took her place. Miss Wright expected to stay only two months, but remained in the school system until her retirement in June 1942.

The small wooden building on Jackson Street soon became inadequate for the fast-growing community. The school board of Washington District—of which South Norfolk was a part—purchased a block of land in Elmsley between A and B Streets and Twentieth and Twenty-second Streets and built the first brick building of eight rooms at a cost of thirty-five thousand dollars. This took place around 1902. By 1906 plans were being made for the formation of a high school.

In 1908 the four-room building in Portlock was built on the east side of the public road that was formerly known as the Berkley-Currituck Turnpike. Also in 1908, Mr. A.H. Foreman became superintendent of Norfolk County schools. Plans were made for construction of a second brick building on B Street. It was completed and ready for use in September 1910. In 1916 a third building was completed at the corner of B and Twentieth

Streets. Two of the buildings were designated for use as the grammar school and the building near Twenty-second Street was used as the first South Norfolk High School. The Waterford School, which had been built on Liberty Street in 1913, was also part of the South Norfolk School system.

On July 31, 1928, the state board of education created a new school division of the city of South Norfolk and on August 6, 1928, Mr. R.H. Pride was elected division superintendent.

When the school on B Street became overcrowded, a six-acre site on Holly Street between Rodgers and Decatur Streets was acquired. A new South Norfolk High School was built in 1929 at a cost of $140,430. The first class entered the school on February 3, 1930.

On January 1, 1951, South Norfolk annexed a portion of Norfolk County. With this annexation the South Norfolk school division inherited the schools of Portlock, Riverdale, Providence and South Hill. The Waterford Elementary School on Liberty Street was already a part of the South Norfolk school system.

In early 1950 the city of South Norfolk purchased twenty-five acres at the foot of Rodgers Street from the Commonwealth of Virginia. It was here that the first Oscar F. Smith High School was built. The school received its first students in September 1954.

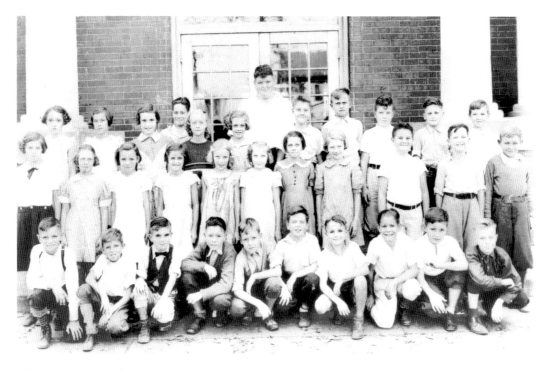

The students in Miss Cowand's 4–A class in October 1937 are, *left to right*: *(first row)* Ray Harrison, Lonnie Lane, [*first name unknown*] Bazemore, Chester Pounds, Donald Leet, Billy Forbes, Soney Pierce, Robert Alkire, Horace McPherson and [*first name unknown*] Dean; *(second row)* Constance Swain, Ruth Castellow, Elsie Holbrook, Marie Etheridge, Jean Johnson, Shirley Carter, Leila Lane, Jean Bagley, Rudolph Sawyer, Linwood Womack and Otis Baker; *(third row)* Mary Elizabeth Dowdy, Marie Waff, Nola O'Neal, [*first name unknown*] Trevathan, Shirley Chappel, Mary Lou Burlas, Carter Lindsey, [*unidentified*], Charlie Brown, Murdock Mason, [*first name unknown*] Black and Carlton Hughes. *Photo courtesy of Richard Spratley.*

Local Education

In September 1994 a new Oscar F. Smith High School opened on Great Bridge Boulevard and Tiger Drive. The original Oscar F. Smith High School then became a middle school.

Private Schools and Academies

During the early part of the nineteenth century public education was practically nonexistent, making private schools a necessity. Actually they were encouraged by the state, and some were established with funds raised by lotteries. The academy period in Norfolk County began with the Somerset Seminary in 1802 and ended with the closing of the Churchland Academy in 1903.

It is not known just how long the Somerset Seminary operated, but most likely it became the Craney Island School in 1810. In 1840 a new building was erected on the same site and was named the Sycamore Hill School. In 1852, still another school was constructed on the same site.

Saint Brides Academy was opened in 1835 and chartered in 1836. It was located in the Hickory Ground section of Norfolk County. The land was donated by Josiah Wilson. This school became a prominent factor in the education of Norfolk County children in primary, elementary and high school work. The academy had excellent teachers who ranked with the best educators in the nation. Probably due to the coming Civil War, Saint Brides closed in 1860.

The Western Branch Academy was incorporated in early 1844. There is no information as to when it was actually established or the length of its existence.

Herbertsville Academy was established at Washington Point, which later became Berkley, in 1844. Classes commenced January 1, 1845. The charge for room, board and tuition was eighty dollars per year.

Ryland Institute, a chartered institution, furnished higher education to young ladies. It was located in the old Hardy Homestead at the foot of Main Street in what is now Berkley.

The Berkley Military Institute (BMI) was in the old Marine Hospital at the foot of Chestnut Street. BMI was coeducational and was really not more than a high school with a military department. B.H. Gibson, a future mayor of South Norfolk, was captain of the school soldiers. The Reverend Robert Gatewood operated a church-sponsored school in a building behind his church in Berkley. In 1912, a public school was built on Poplar Avenue and was named for Robert Gatewood. The many private schools in Berkley were well patronized until about 1900 when the progress of public schools made them almost unnecessary.

There were several small private schools in the village of South Norfolk. In 1893 the Elizabeth Knitting Mill was operating on Park Avenue between Perry and Porter Streets. Since there were no labor laws at that time, a number of children were employed at the mill and usually worked six day a week. When the depression of 1893–1899 occurred, the mill operated only three days a week—Thursday, Friday and Saturday. Mrs. Edward Williams, who lived on Porter Street, had been teaching her own children. Since there were three days each week that the children could not work, their parents asked Mrs. Williams if she would teach them. She agreed, and for two years the second floor of

A History of Chesapeake, Virginia

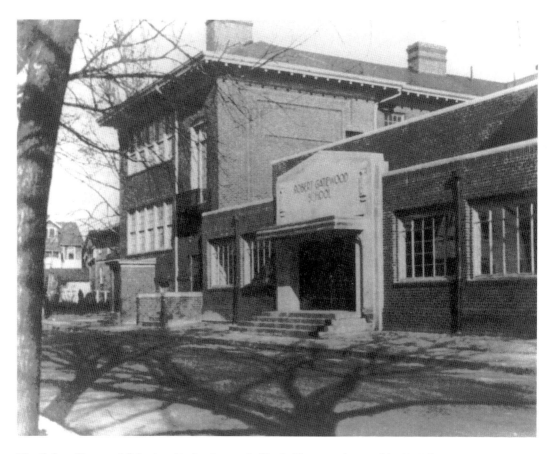

The Robert Gatewood School on Poplar Avenue in Hardy Homestead opened in 1912. It was named for Reverend Robert Gatewood, a clergyman and former headmaster at the Norfolk Academy. The school, which stood on the avenue lined with poplar trees, closed in the 1970s and was demolished about twenty years later. *Courtesy of Sargeant Memorial Room, Norfolk Public Library, Norfolk, Virginia.*

her home was used as a school. For her services she received one dollar per month from each student.

The land for the Churchland Academy was purchased in March 1873. The plot included approximately five and a half acres. The classroom consisted of a large, wooden frame building and another building adjacent to it housed the teachers.

The academy was not successful until it was incorporated in 1883. The subjects offered were English, geography, history, mathematics, Latin, Greek, French, German and natural science. The cost for board, laundry, fuel and light for the term was $150. Tuition charges were dependent upon the course of study. Board and tuition payments were required quarterly. A discount was given when more than one student from a family attended.

The faculty consisted of four members, of which two held master's degrees and taught the academic subjects. One taught primary subjects, and one taught music.

With the rapid growth of the public school system and the introduction of public high schools, the need for private schools began to decline. With the entrance of the twentieth century, the academy period came to a close.

Chapter V
Early Tidewater Religions

The first report of religion in the area was found in a legal document dated May 15, 1637, when mention was made of an Anglican Parish in Lower Norfolk County. The Anglican Church was the Church of England, and under instructions dated July 24, 1621, the governor was required to keep up the religion of the Church of England in the colony of Virginia.

Today, the city of Chesapeake has within its boundaries more than fifty different denominations. Even with this large variety of churches, the main religions include Baptist, Methodist, Presbyterian, Lutheran, Congregational Christian and Roman Catholic. The Jewish population attends services in Portsmouth or Norfolk. In my youth the original Mikro Kodesh Synagogue was on Eleventh Street in Berkley not far from the dividing line between Berkley and South Norfolk.

Before the American Revolution, the Church of England was the predominant church in the colonies. What was then known as the Anglican Church became the Episcopal Church. The first church in the Anglican parish was constructed at Lynnhaven in 1638. At this time there are only two Episcopal churches in Chesapeake.

The first church in what is now Chesapeake was established in 1639, but was not built until 1661. It was the chapel of ease for the Elizabeth River Parish, and it was located on the Southern Branch of the Elizabeth River between Jones Creek and Scuffletown Creek in South Norfolk. Called the Southern Branch Chapel, it was moved in 1701 to Great Bridge and was located at the southwest corner of what are now Battlefield Boulevard and Cedar Road. In April 1728 it was still the Southern Branch Chapel, but by October 1749, according to records, its name had been changed to the Great Bridge Chapel. In 1750 it was enlarged, and in 1752 a well was dug on the property.

The chapel was the victim of considerable damage from cannon fire during the Revolutionary War, especially during the Battle of Great Bridge. The second Virginia Regiment had used it as a fort. It is not known for sure, but apparently the chapel was not abandoned and dismantled until 1845, after having once again served as a chapel of ease, this time for the Saint Brides Parish.

Saint Brides, which included the entire county south of the Eastern Branch of the Elizabeth River and east of the Southern Branch, was established in 1761. Saint Brides Church, sometimes called the Northwest Church, was built in 1762 and remained in the area until 1853. James Pasteur was its first minister and he served from 1761 to 1774. John Portlock and William Smith, according to a deed of 1763, were the first church wardens, and Malachi Wilson and Willian Happer were named in a deed dated 1768. The names of the vestrymen are listed in a Norfolk County court order of 1761.

The church or chapel was not used much after the Revolution. Reverend John H. Rowland, who was minister in 1775, was a Loyalist and was reported to have assisted Lord Dunmore with information about the activities of the parishioners. Because of his loyalty to the Crown, his congregation became permanently alienated from the church. It is not known whether Rowland was tarred and feathered and run out of town, but historians have said that he went to New York, where he became chaplain for the Loyalist Second Battalion of New Jersey volunteers.

Captain James Wilson, a vestryman in 1761, gave land to be used for the construction of the Hickory Grove Methodist Church, which was founded in 1790. This is now the Hickory United Methodist Church.

In 1911, the Episcopalians built a church at the corner of Dinwiddie Street and Poplar Avenue in the Berkley section of Norfolk and gave it the name Saint Brides. In 1923, Saint Brides Church merged with another Episcopal Church and in 1960, they moved to the 600 block of Sparrow Road in what is now the Washington Borough of the city of Chesapeake. This church is responsible for starting Saint Thomas Church on Mann Drive in Great Bridge. Saint Thomas was a mission in 1956 but became an independent parish on January 20, 1975.

The Puritan (Protestant) movement in England was responsible for the rise of several denominations, which included Presbyterians, Methodist and Baptist. It was during the Civil War in England when the Roundheads were pitted against the monarchy that Presbyterianism became the legal form of ecclesiastical government in the established church.

Presbyters (priests or elders) governed the individual churches as opposed to the Episcopal form of government, where a diocese comes under the jurisdiction of a bishop. Presbyterizing of the church was brought to the American colonies as early as 1645, and a minister from the Elizabeth River Parish was dismissed because he favored it. Some colonies welcomed Puritans, while others dismissed them. This nonconformity continued in Norfolk County even after the monarchy was restored in 1660. The Presbyterian denomination was strengthened by an influx of Scots both before and after the Revolutionary War. There are about five Presbyterian churches in Chesapeake today.

Methodism arrived in Norfolk County about 1770. At that time a Mr. Cutherell opened his home in Great Bridge to friends and relatives so that they may meet in the Methodist manner for singing and praying. It was a revival movement within the Anglican Church. The Cutherell home, which was destroyed by fire in the mid-1800s, was less than a mile from where the present-day Oak Grove Methodist Church stands. It was in 1763 that people

from Norfolk County went to Portsmouth to hear their Methodist preachers, and in 1772, they went to hear preaching in Norfolk.

On August 10, 1772, Joseph Pilmoor, a famous Methodist preacher, left Norfolk and traveled to Great Bridge, where he spoke to a group at the home of a Mr. Manning. Pilmoor later returned to Norfolk County and preached at Western Branch, Grassfield and Indian River. He organized a Methodist society at New Mill Creek and revisited it on April 14, 1773. Other ministers that preached in Norfolk County included William Watters, Robert Williams, Francis Asbury and Edward Bailey.

On February 11, 1804, Bennett Armstrong and his wife, Jinny, donated a half acre of land, about a mile from where the Oak Grove Church is now located, for the building of a Methodist Episcopal church. The first Methodist church was built on this site about four or five years later. It has been said that the Cutherell meetinghouse was moved on rollers, probably logs, to the present site of the Oak Grove Church in 1842.

During the Civil War, a nearby family hid the communion silver, carpet and the church Bible in their home for safekeeping before the Yankees arrived. After the war, the church and the people were impoverished. One week in 1872, only nine people attended church and the collection was fourteen cents. In 1869, the church had seventy-six members, and in 1900, the enrollment had dropped to seventy-two. After those hard times, the church membership began to grow, and in 1962, the congregation helped start the Great Bridge Methodist Church. Most congregations at this time were without much hard cash, but there were some areas of Norfolk County that were hardly touched by the war. The history of those areas during Reconstruction tells of relative ease and plentitude.

The Baptists established the Blackwater Church in 1774 and began their first church in Norfolk County in 1782. The church was called the Upper Bridge Church and later the Northwest River Bridge Church. Today, it is the Northwest Baptist Church and is located at 848 Ballahack Road. In the beginning it was served by itinerant preachers, and its first regular preacher was Elder Jacob Grigg, who remained there until 1802. In 1803 Elder Dempsey Casey became pastor, serving its fifty-two members. In 1818, the original meetinghouse was destroyed by fire. A new building was completed in 1821 and its present name was adopted at that time.

The Northwest Church was responsible for establishing two other early Baptist churches. They were Pleasant Grove, founded in 1845, and Lake Drummond Baptist Church, in 1850.

The Churchland Baptist Church was formed in old Nansemond County in 1785 as Shoulder's Hill Baptist Church. It moved six miles into Western Branch in 1829, at which time it became known as Sycamore Hill Baptist Church. It is now located at 3031 Churchland Boulevard.

After the Civil War, many other Baptist churches came into being in what is now the city of Chesapeake. Included among these are Centerville Baptist Church in 1872; Elizabeth River in 1873; South Norfolk Baptist in 1893; and Raleigh Heights in 1897.

The Great Bridge Congregational Christian Church was founded in 1859, when a small group of Christians built a meetinghouse for worship. The little church, renovated in 1905 as a chapel, was built from hand-hewn timbers. The logs were so solid that, until destroyed by fire in 1973, the structure had been used by all subsequent generations of the church's members

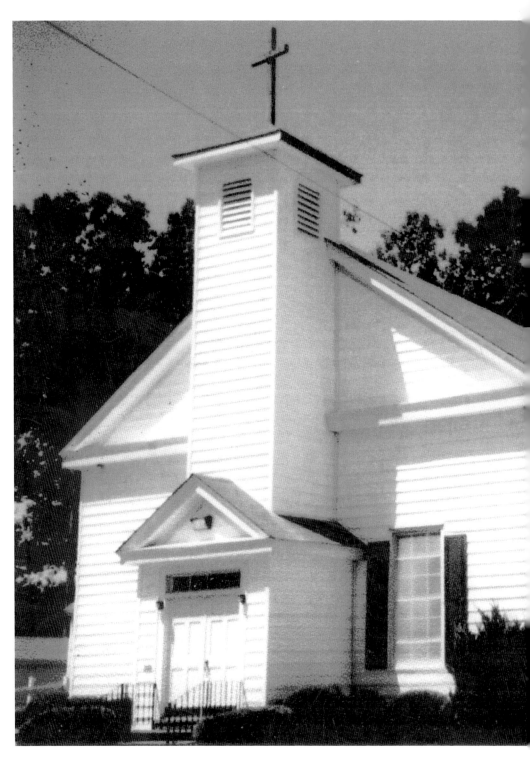

Joliff United Methodist Church, which is located at 1836 Joliff Road in Western Branch, has roots going back to circa 1798. At that time, the church was known as Joliff Meetinghouse. The present church was erected around 1850 and has been remodeled several times since. *From the author's collection.*

Early Tidewater Religions

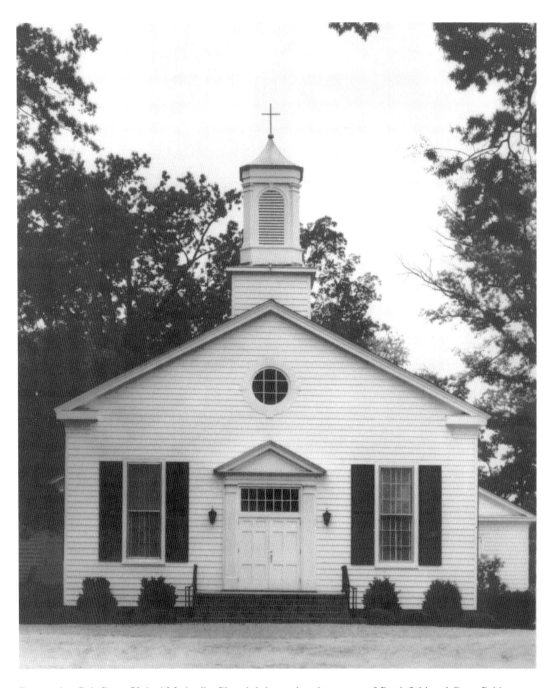

Present-day Oak Grove United Methodist Church is located at the corner of Battlefield and Great Bridge Boulevards. Methodism came to Norfolk County around 1770 when meetings were held at a Mr. Cuthrell's home, which was less than a mile from the present location of Oak Grove Church. This church was erected in 1852 and has been enlarged several times throughout the years. *From the author's collection.*

Early Tidewater Religions

and by the Roman Catholic Prince of Peace Mission from 1971 until it built its own structure in 1977. Hurricane Barbara toppled the steeple of the church in October 1953.

The timbered church, called the Methodist Protestant Church at Berea in those days, had earlier survived the ravages of the Civil War. In 1861, it fell into the hands of Union troops and was converted into a horse stable.

In 1870, Berea Church turned down a proposal to go along with a union of the Methodist Protestant and Methodist Episcopal churches in Virginia. Instead, the church voted in August 1871 to transfer to the Christian church. It was not until 1955 that it changed its name from Berea Church to the Great Bridge Congregational Christian Church. When the Congregational Christian churches and the Evangelical and Reform churches united to become the United Church of Christ, Great Bridge voted to join in the union. Growth was so great that the church was forced to build a new sanctuary, which was dedicated on December 9, 1962.

When the merger took place in 1963, there was one Roman Catholic church in the new city. The first Catholic church, Saint Mary's at Sunray in the Bower's Hill section, was founded in 1912 by two dozen Polish families who immigrated here between 1908 and 1912. Saint Therese's Roman Catholic Church was founded in Portsmouth in 1954, but moved into Chesapeake in 1972. Prince of Peace began meeting in the chapel of Great Bridge Congregational Christian Church on Easter Sunday in 1971. It was founded first as a mission of Saint Matthews's Church, which started in Berkley and is now in Virginia Beach. Today, Prince of Peace has its own church at 621 Cedar Road. Other Catholic churches in Chesapeake include Saint Stephen Martyr, Robert E. French, Saint Benedict's Chapel and Tridentine Rite Chapel.

It was in 1895 that a Mennonite family by the name of Swartz and two other families from Michigan settled in Norfolk County. In 1910, the agriculture-oriented religious group built the Mount Pleasant Mennonite Church at 2041 Mount Pleasant Road. Other Mennonites from Pennsylvania and Maryland later joined them. Modern life has encroached upon their time-honored farming vocation, and many have entered other fields of employment. Residential and commercial development has led to prosperity for some of Chesapeake's Mennonite families. Some have entered the fields of medicine and law and others have moved to other parts of the country.

The Lutherans arrived in Chesapeake in 1964. Until recent times the Lutheran church was mainly an immigrant church, following the German and Scandinavian migration to America. The Lutherans were in the valley of Virginia during colonial times; however, it was on May 20, 1894, that the first Lutheran church was established in Norfolk. It was on Colley Avenue. In 1908, the First Lutheran Church in Portsmouth was located at Washington and King Streets. There are now four Lutheran churches in Chesapeake—Apostles Lutheran Church, Faith Evangelical Lutheran Church, Grace Lutheran Church and Chesapeake Community of Hope.

There are many other churches in this large, populous city of Chesapeake. Those that have been highlighted here are representative of the earlier religions in the area. The Lutheran church was included to show that the history of religion in Chesapeake is still being written. In early Norfolk County and South Norfolk most of the community activities revolved around the churches. They were not only places of worship but were

also places of entertainment. When there was no house of worship within traveling distance, members of the community, sometimes with the help of an established church, came together to build one

Chapter VI

South Norfolk

"South Norfolk or So No, which is it going to be?" That was my opening line when I spoke at the local Ruritan Club on Monday evening, February 26, 2007. A group of about a hundred members stomped their feet and booed me. South Norfolk, not So No, was my hometown and theirs. It took me a few minutes to convince them that my opening remark was made in jest, and that the only people in favor of a name change are those who never lived here or those who are too young to remember the good old days in South Norfolk. I finally made my speech and was able to escape in one piece.

I have written several books about the history of South Norfolk. Volumes one and two of *South Norfolk, Virginia 1661–2005, A Definitive History* and volume three, *South Norfolk, Virginia 1661–2005, A Visual History*, are still available in local bookstores. Copies of my older books can be found at the South Norfolk Memorial Library on Poindexter Street, or if you prefer to own a copy, a few can be found on Amazon. With that in mind I will not attempt to include another complete history of South Norfolk in these pages; however, since this is a book about the city of Chesapeake, which would not exist had it not been for the city of South Norfolk, I would like to include a few words of wisdom in this space. I hope you will allow me to incorporate here a few highlights of my hometown.

In the early pages of history we find that this area had its beginning with the construction in 1661 of the Southern Branch Chapel of the Church of England. That's where all the early records were kept. Actually, the church had been organized in 1639, but the chapel, which was built in the vicinity of present-day Lakeside Park, was not built until 1661. In 1701 the chapel was moved to Great Bridge and was located at what is now the corner of Battlefield Boulevard and Cedar Road. According to historic records, by October 1749, the name had been changed to the Great Bridge Chapel. At that time Great Bridge was a small crossroads.

The earliest family records are those of the Portlocks. Although records show that John Portlock first visited the area in 1685, according to unofficial information passed down through the years, members of the family were probably in the area as early as 1634. John Portlock made several visits to the colony of Virginia. On subsequent visits

A History of Chesapeake, Virginia

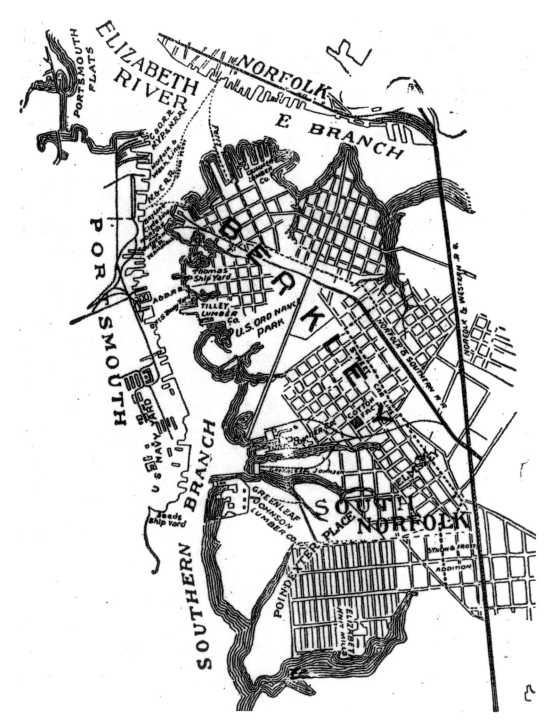

When this map was drawn, Berkley and South Norfolk were communities in Washington Magisterial District, Norfolk County. Five years later Berkley would be annexed by the city of Norfolk. A close look reveals that South Norfolk had not grown very much. Poindexter Place, Synon and Frost Addition and Elmsley Place covered most of the land. The Elizabeth Knitting Mill was operating in South Norfolk and the streetcars were running from the ferry dock in Berkley to South Norfolk. *Courtesy of Stuart Smith.*

he brought other families with him, and for each person that settled in the colony John received fifty acres of land from the Crown of England. Eventually the Portlock property extended from what is now the Berkley section of Norfolk, along the Southern Branch of the Elizabeth River and all the way to Great Bridge. Throughout the years other members of the family acquired large amounts of land in what would become Norfolk County and South Norfolk.

The early settlers were mostly farmers, and the area remained primarily agricultural through the colonial period and the Civil War. Another prominent family that settled here before the Civil War was the Poindexter family. Information tells us that Carter W. Poindexter had served as an admiral in the British Navy before relocating to the area. He built his first home, which he named "the Anchorage," on the waterfront across from the Gosport Navy Yard. This later became the Norfolk Navy Yard.

Carter and Mary Poindexter were the parents of three children—Reginald, Parke and Bettie. Reginald has been credited with naming the community South Norfolk sometime before 1890. Poindexter Street was named for the family, and the admiral was responsible for naming many of the other streets in South Norfolk. Among them are Jackson, Rodgers, Stewart, Hull, Bainbridge, Perry, Porter, Lawrence, Barron, Truxton and possibly a few others. Guerriere Street was named for the HMS *Guerriere*, which was captured by Captain Isaac Hull and the crew of the USS *Constitution* during the War of 1812. A study of the War of 1812 reveals that most of the original streets in South Norfolk were named after sea captains who fought in that war.

The Poindexter family later moved from the waterfront to a two-story house on what is today the 1000 block of Ohio Street. Their next move was to a house that had belonged to J.P. Andre Mottu. Mottu, who had served as a consul from Belgium, sold his very large house and acreage—which included the present-day 1200 blocks of Rodgers, Decatur and Stewart Streets and all the land in between—to the Poindexters. Mottu then bought the Colley Farm in Norfolk, which was in the Atlantic City area on the west side of The Hague, near Christ and Saint Luke Church.

Carter Poindexter and his son Parke were responsible for bringing the first manufacturing enterprise of importance to South Norfolk—the firm of Johnson & Waters, of Baltimore, which afterwards became the Greenleaf Johnson Lumber Company.

It was not until after the Civil War when railroads began to bring coal and produce from the West and South that new industries located along the Eastern and Southern Branches of the Elizabeth River. Edward Munro Tilley, a former captain in the Northern army, settled in Berkley and went into the lumber business. In 1890, he had his new home built on Chesapeake Avenue at the corner of Guerriere Street in South Norfolk. The house, which still stands, has twenty-two rooms and seven fireplaces. After Tilley's death on December 21, 1917, Q.C. Davis and his family moved into the house.

In 1890, the Chesapeake Knitting Mill was built on land bordering Berkley and South Norfolk. In 1892, the Elizabeth Knitting Mill was constructed in South Norfolk on land where the Rena B. Wright School is now located. Both mills manufactured what we call union suits or long johns, the kind that button down the front and have a trapdoor in the back. They also made sweat shirts. Most of the output from both mills was shipped to Northern markets where the winters were extremely cold.

Mass Meeting

On Behalf of Candidacies of

MAYOR B. H. GIBSON
W. E. BEEDIE
H. E. WINSTON

Woodmens Hall, South Norfolk

22nd Street

Thursday Night 8.00 P. M., May 18, 1933

SPEAKERS

Many prominent ladies and gentlemen of South Norfolk will address the Mass Meeting on behalf of Mayor B. H. Gibson, W. E. Beedie, H. E. Winston and the City Administration.

SPECIAL MUSIC BY SOUTH NORFOLK ORCHESTRA

Every voter of South Norfolk interested in good government is especially invited to be present.

Political Fire Works a plenty will be Exploded

DON'T MISS IT

This political meeting was typical of many that were held at the WOW Hall on Twenty-second Street in South Norfolk. Those were pistol-packing days—if you owned one you carried it. Mayor Benjamin Harry Gibson was reelected but died in 1936. J. James Davis was chosen to finish Gibson's unexpired term and went on to serve twelve years as mayor. *Photo courtesy of Winston Smith.*

South Norfolk

Eventually both knitting mills came under the ownership of William Sloane. Sloane married Florence Knapp and they moved into their new home at the corner of Chesapeake Avenue and Ohio Street in 1895. The home still stands at 1203 Chesapeake Avenue. This home and the one built for the Tilley family both are in the South Norfolk Historic District.

South Norfolk had its beginning as a small village and grew to become a town in September 1919. Two years later it became a city of the second class and after annexing the town of Portlock in 1951, it became a first-class city.

The Great Depression hit South Norfolk hard like it did most of the country. But out of all the economic problems, there arose a real closeness among its citizens. There was a kind of evenness of resources—meaning that most family incomes were about the same—and it was a society made up largely of blue-collar workers.

In September 1934 my mother escorted me to the school on B Street and enrolled me in the first grade. My teacher was a tiny lady by the name of Shanah Pulliam. For the most part all went well the first day. But the following day I had an embarrassing accident and Miss Pulliam sent me home to get a change of clothes. I returned to school in time for the afternoon classes.

Families were the important connections in our city. Churches and schools were an important part of the community. In the earlier years very few people went beyond

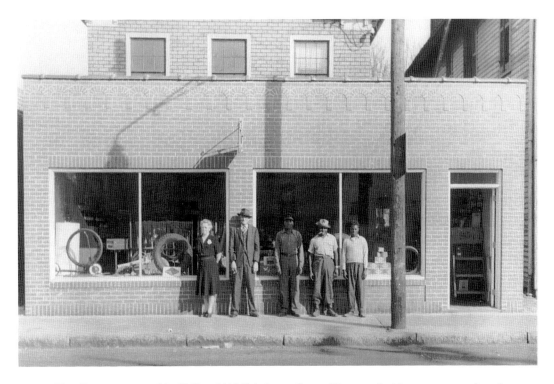

Powers Tire Company opened in 1945 at 1410 Poindexter Street. The store had been constructed on the front, downstairs part of H.E. Winston's home, which had been built in 1907 at a cost of seven hundred dollars. The building to the right of the store is the Odd Fellows Hall. The man, *second from left*, is Barney Powers. Around 1947, the business became Platt's Tire Store and in 1954, it was Paul's Tire and Appliance Store. *Photo courtesy of Winston Smith.*

A History of Chesapeake, Virginia

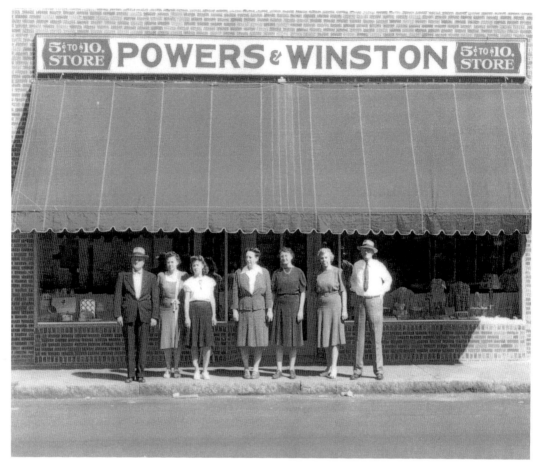

In 1946, H.E. "Fats" Winston and Barney Powers opened Powers & Winston Five- to Ten-Cent Store at 1408 Poindexter Street. Those pictured here are, *left to right*: H.E. Winston, [*unknown*], Anna Mae Altman Morrison, possibly Mrs. Ross, Lotti Sykes, Effie Ferbee and Barney Powers. The occasion was the celebration of the enlargement of the store in 1949. *Photo Courtesy of Winston Smith.*

high school and many did not advance beyond elementary school. A lot of this changed after World War II when returning veterans took advantage of the GI Bill and went to college.

Early South Norfolk was teeming with stores of all kinds. There were several that remained in business for the better part of a century. Sam Wilson established his family grocery business on Liberty Street in 1888. The market remained in business for about seventy-five years. Dean Preston opened his drugstore on Liberty Street in 1913. The pharmacy operated for seventy-six years, closing its doors in June 1989. Overton's Market ceased operation in January 1985 after more than sixty-five years.

In addition to these "longtimers," there were many smaller stores as well. There were neighborhood grocery stores, dry goods stores and even a department store. Tabb's Department Store was on Poindexter Street until the Great Depression forced the brothers

South Norfolk

This 1949 photo shows the interior of Powers and Winston's store after an expansion took place. Those that can be identified are, *left to right:* "Fats" Winston, [*unknown*], [*unknown*], Barney Powers, [*unknown*], Mrs. Ross, [*unknown*], [*unknown*] and the two ladies facing the cash register are Effie Ferbee and Lotti Sykes. *Photo courtesy of Winston Smith.*

to close. There were several barbershops where you could get a good haircut for fifteen cents. Today it is hard to find a barbershop at any price. Let's take a look at the history of the three older businesses. Each had its beginning on Liberty Street.

Sam W. Wilson Market

S.W. Wilson Family Groceries, Hay, Grain & Feed opened for business in 1888. The first store was in the front of a two-story house on Liberty Street near the Norfolk and Western Railway crossing. The capital stock at that time amounted to fifty dollars. Deliveries were made using a horse-drawn buggy. As the years passed, the business began to grow, and in 1904 Mr. Wilson purchased J.A. McCloud's South Norfolk Market. Having started in 1873, McCloud's Market was the first business in South Norfolk.

Continued growth necessitated a larger building and eventually the store was located at 161 Liberty Street. The name was then changed to S.W. Wilson South Norfolk Market. In 1920, the name was changed again. This time it became known as S.W. Wilson & Son. By this time Mr. Wilson had acquired a truck to make deliveries. Around 1928, the store was remodeled and enlarged. The name was then changed to S.W. Wilson & Sons South Norfolk Market.

In 1937, the building and stock represented an outlay of about twenty thousand dollars. In 1930, the street numbers in South Norfolk were changed and the address of the store was now 1001 Liberty Street.

Sam Wilson Sr. died suddenly in 1931. The market was then operated by his son Sam Wilson Jr. and his wife Kathleen. Sam Wilson Jr., like his father, died suddenly and at a rather early age. After his death, Kathleen ran the store until it closed in the 1960s. Wilson's grocery store was one of several landmarks in the city of South Norfolk.

Preston's Pharmacy

Around 1890, J.T. Lane operated a drugstore on Liberty Street in the area that eventually became known as Lane's Row. In 1913, he sold the business to W. Dean Preston. Preston operated his drugstore at that location for twenty-five years. In 1938 he built a new store at the corner of Poindexter and B Streets. The location of the front door was such that it faced Chesapeake Avenue.

For more than three-quarters of a century, Preston's Pharmacy made deliveries. The motto was "Phone Preston—He will send it." In earlier years the phone number was Berkley 335.

The corner pharmacy was the gathering place for local teenagers or, as they became known, "drugstore cowboys." It was a place to meet friends, sip a coke or drink a milkshake or limeade. Also if you had a headache you could order a coke with ammonia or capudine. In my case, it was a place to find a girlfriend. Preston's is where some others and I met our future wives.

Behind the counter was an enlarged 1945 photograph of nine people walking off the streetcar on B Street. This was not a regular stop. Dean Preston asked John "Captain Mac" McGlaughan, the motorman, to stop for the photo. Throughout the years many people have insisted that they are in the picture. Captain Mac's daughter, Jewel, said she could all but prove that she was the girl wearing the plaid dress, and most likely she was. The only thing I am sure of is that I am not in that photo.

Preston's Pharmacy remained on that corner for fifty-one years. After a total of seventy-six years, the independent drugstore closed in mid-1989. Dean Preston sold the store to George White in 1946 and Mr. White sold it to James L. (Jimmie) Marshall in 1972. By that time the large chain stores had begun to put the small independent drugstores out of business. The chain stores could actually sell their products for less than what the independent stores paid for them. The closing of Preston's Pharmacy meant the removal of another landmark from what at one time had been a thriving city.

South Norfolk

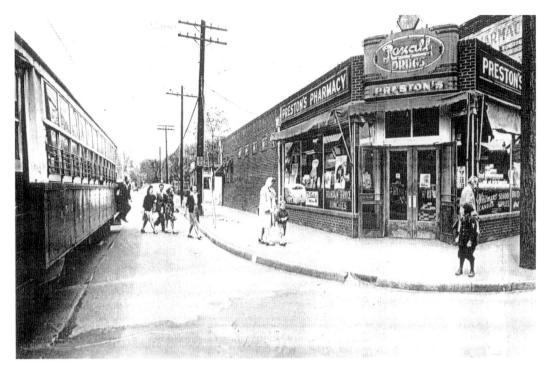

For those who have read my books, this is a familiar scene—the enlarged version hung on a wall behind the counter in Preston's Pharmacy. As you can see there are nine people involved in this staged photograph. Throughout the years literally dozens of people have insisted that they are in the photo. I will assure you of one fact: I am not in the picture. *From the author's collection.*

Overton's Market

Mr. Sam M. Overton came from Aydlett, North Carolina, in 1918, where he had been tending farm along the Currituck Sound. The family rented a house on Eleventh Street in Berkley. While in Berkley the children attended the George Washington School on Fifth Street, which later became known as Grayson Street. Not liking to pay rent, Mr. Overton bought George Grimes's house in what is now the 1400 block of Poindexter Street in South Norfolk. In 1919 he opened a small fish shop on Liberty Street.

Mr. Overton's son Alton graduated from South Norfolk High School in 1923. He then attended the College of William and Mary for two years, leaving on June 6, 1925. At that time he went to work as a traveling salesman, a position he held for ten years. Growing tired of being away from home for long periods of time, he quit that job, came home and went to work with his father.

After Alton returned home, a decision was made to convert the front two downstairs rooms of the house on Poindexter Street into a grocery store. Alton mixed the concrete himself, and with the use of a wheelbarrow, he was able to lay the entire floor. Then with the help of a Mr. Berry, a carpenter, they completed the store on Poindexter Street. On February 16, 1936, Overton's Market was moved from Liberty Street to Poindexter Street.

The first year business was fairly good; the second year it was even better. This was not the case for their neighbor, who ran Tabb's Department Store next door. The Great Depression had forced the Tabbs to close their business. They were not able to make the payments on the building and it was repossessed by the Mutual Federal Savings and Loan. The building was vacant for a while and then in 1937, A.J. Legum rented it and opened the Hub Furniture Company at that location.

In 1939, Mr. T.J. Massengill, a salesman for the Armour Company, and also a member of the board of directors of the Mutual Federal Savings and Loan, approached Mr. Alton Overton and asked him to buy the building that had been Tabb's Department Store. He replied that he and his father had reinvested most of their earnings in the business and therefore did not have the money. Mr. Massengill asked that he at least meet with John Lesner, president of the savings and loan, and discuss the matter. The meeting took place and the Overtons purchased the building for sixty-five hundred dollars with no down payment, and also received the funds needed to convert it into a grocery store. The deal was settled with an old-fashioned friendly handshake.

For more than sixty-five years there was an Overton's Market in South Norfolk. In the beginning the Overton brothers rode bikes to customers' houses, took their orders, returned to the store, filled the orders and then delivered them. Eventually the family owned thirteen stores in the Norfolk, Portsmouth and South Norfolk areas.

During World War II, Alton Overton served two years and nine months in the navy. After the war he returned to the store on Poindexter Street where he bagged groceries, operated the cash register and managed the store. He also served on the South Norfolk city council and refused the pay that went with the position.

In 1963, the unions came and tried to organize Overton's employees. The Overtons had always taken care of their employees the old-fashioned way, on an individual basis. That arrangement had always worked well until the federal government intervened.

Their stores were the first in the area to have air conditioning, profit sharing and employer-paid health insurance. With all the benefits offered by the Overton family, the employees had nothing to gain from the union. There were other trends in business that Overton resisted to the very end. He never sold beer and never opened the store on Sunday.

Shortly after the fight with the unions, the family began selling off the grocery stores. The Poindexter Street store closed its doors on December 31, 1984. The Berkley store, which was operated by Alton's brother and his nephew, remained open for a while. For many years Alton Overton took care of the shut-ins. After the South Norfolk store closed he continued to get groceries from the Berkley store and deliver them to these people.

It was my pleasure about twelve years ago to visit Mr. Alton Overton at his office. We must have talked for more than two hours. Most of what I have written here, I learned that day. Mr. Overton passed away on August 28, 2003, at the age of ninety-eight.

After the Merger

After the merger with Norfolk County on January 1, 1963, South Norfolk began to go "downhill." Most of the industries along the waterfront moved or closed. Many of its early families relocated to other parts of the new city, and the old, beloved city became loaded with absentee landlords and drug dealers. Revitalization has been a "hot topic" for several years. A few improvements have been accomplished and there are plans for others. If all takes place that is planned, it will take at least twenty years. I often spend time walking the streets with new property owners, newspaper journalists and contractors who want to know what old South Norfolk used to look like. Some of them have purchased buildings in what was once the downtown area. I hope they are serious about restoring those old properties.

In January 1989 South Norfolk was named to the National Register of Historic Places. The district boundaries are loosely defined as including Richmond Street on the south, Seaboard Avenue on the east and Hull Street on the west. The northern boundary runs along Poindexter Street and also includes much of the old business district. These boundaries are probably subject to change.

Here I would like to include a few notes about the early community of South Norfolk, most of which can be attributed to the late Lennon H. Newberry who served as chief of the volunteer fire department.

A standard-gauge horsecar line began operation in Berkley on February 3, 1888. The route was from the Berkley ferry to the Belt Line Railroad. Soon thereafter the line was extended into South Norfolk. In 1893, the streetcar company, which was known as the Berkley Street Railway and Light Company, consisted of twenty head of horses and mules and seven cars. The early horsecars were able to carry eight passengers, four on each side. At that time the stables were in that area behind the present-day South Norfolk Baptist Church. In 1894 the horsecars were replaced by electric cars, which were operated by the use of an overhead trolley. The early electric cars could carry sixteen passengers, eight on each side. The power plant that was operated by the company was located at the old Tunis Lumber Yard in Berkley.

In the late 1800s and the early 1900s many present-day streets in South Norfolk were shorter and came to an end in wooded or marshy areas. In the late 1890s the area along Seaboard Avenue from Phillip Street to Holly Street was a horseracing track and was referred to as the half-mile track. Around 1900, Chesapeake Avenue did not extend past Holly Street, and Jackson Street came to an end just past Park Avenue. Decatur Street was only one block in length, and that was from Buchanan Street to Eighteenth Street— later Decatur Street was extended to Poindexter Street. At that time, Hull Street began at Poindexter Street and came to an end at Park Avenue. In 1915 Rodgers Street did not extend past Ohio Street.

In 1916 several South Norfolk businessmen purchased what had been the Mottu/Poindexter property and extended Rodgers Street past Ohio Street. At that time, the new owners disassembled the large house and divided the land into lots. This area then became known as the Beechwood tract. There was enough lumber in the large old house to build several smaller ones that still stand today.

In the early 1900s Stewart Street came to an end at Park Avenue and a footbridge was used to cross a creek to Hull Street. In my earlier years I saw the marshland filled and Stewart Street extended to Holly Street. Several homes were built on this filled land.

Around 1910, a large baseball field occupied much of the land that is now Park Avenue and the 1500 and 1600 blocks of Chesapeake Avenue.

Early Liberty Street, like all the others in South Norfolk, consisted of dirt and shells. In the dry summer months the streets were dusty and in winter, when there was snow and rain, they were muddy up to a person's knees. Liberty Street did have wooden boardwalks on one side that ran from the Norfolk and Western Railroad tracks to the Belt Line Railroad tracks near the Berkley line.

Some of the following stories should probably appear in a novel like *Peyton Place*.

I was born upstairs at the home of the Young family at what was then 155 Commerce Street in the second-class city of South Norfolk. About two years later, in 1930, my family moved to 608 B Street in one side of a two-story double house with no utilities. There was no electricity. There was a pump in the kitchen and the bathroom was an outhouse in the backyard. In April 1932 my parents bought the house at 1119 Seaboard Avenue. It was a two-story house with all the modern conveniences that were available at that time.

My older brother Jesse was born on Collingwood Avenue in that section of South Norfolk that was called Oakdale. Although the street is still there, it has changed beyond recognition. Jesse and I had two younger sisters, Virginia and Margie. Virginia was born while we were living on B Street and Margie was born about a year after our move to Seaboard Avenue. Both Jesse and Virginia passed away in 1995 at what I call rather young ages.

In my youth, J. James Davis was mayor of South Norfolk. Joe James, as he was called, was a practicing attorney with his office upstairs over the Merchant and Planters Bank. The bank vault on the first floor was located directly beneath Joe James's desk. He often told people that his *ass*ets over one million dollars.

Prior to the 1920s, as the story goes, there was a car dealer in our beloved city that sold his wife to one of the local doctors. I wonder if he threw in a new car as a bonus.

During Prohibition there were several local places where one could purchase booze. I understand that one place was the furnace room of a local doctor's office.

Throughout the ages, birth control has been a serious topic of discussion. Did you know that as recently as the 1930s the sale of condoms was illegal? However, for those with a real need they could sometimes be acquired through mail order, and if that was too much trouble, there was always the coat hanger lady whose services could be had for a nominal fee. In case of an emergency, she always had a doctor on call.

During the Great Depression, the numbers racket was very popular. It was also illegal.

The Grand Theatre was always a great place to go for entertainment—a lot of it took place in the back row and not on the screen. Several conceptions were known to have taken place in the lady's restroom after the theatre closed for the night.

Money Point on the Elizabeth—
Its History and Development

The Elizabeth River was named for Princess Elizabeth Stuart, daughter of King James I of England. There are three branches: Eastern, Southern and Western. In the early years, fish, oysters and crabs were harvested from the waters of the Elizabeth. General Robert E. Lee was a lover of oysters, and when in the area, he would carry a barrel home with him. He described them as "finely flavored and as plump as an egg." At other times, he would have his former adjutant Colonel Walter H. Taylor ship him a barrel. Soon after the Civil War, the waterfront became filled with industries dealing in lumber, creosote, fertilizer, guano and oil. These industries were later joined by others such as chemical, cement and even stockyards. By May 1, 1913, the Norfolk & Portsmouth Beltline Railroad was serving seventy-one commercial enterprises along the Southern Branch. While they provided employment for the local citizens, they also polluted the river. Today, much of the property along the Elizabeth is vacant and there is a movement to clean the river and restore the waterfront.

How did Money Point receive its name? According to information from the Portlocks, the earliest area family on record, the pirate Bluebeard buried his money and other loot along the shores of the Elizabeth River and because of this, the area became known as Money Point. Since the name Bluebeard was given to a fairy tale villain by C. Perrault it is quite possible that the pirate involved was not Bluebeard but was in fact Edward Teach (or Tech), also known as Blackbeard, instead.

When the name Money Point is mentioned, most people immediately associate it with that area at the west end of Freeman Avenue in the Portlock section of the old city of South Norfolk. Money Point actually is the name given to approximately 330 acres along the Southern Branch of the Elizabeth River.

From the late 1800s through the mid-1900s the area from Bainbridge Boulevard along Freeman Avenue towards the Elizabeth River was mostly residential. It has been reported that at one time it was known as Reidsville; however, just prior to 1920 it was known as Buell, Virginia. That was the mailing address. The local post office was in the back of Larry Costen's grocery store. His niece was the postmistress. After the Portlock Station was built on Godwin Avenue, the post office was moved to that location.

The area that included Money Point, Buell and Reidsville was a close-knit, small community with that small-town flavor. Homes lined Freeman Avenue and other prominent streets nearby. Some of the merchants with businesses on Bainbridge Boulevard lived in or near Money Point. The Hassell and Cahoon families are two that come to mind. Some of the residents also worshipped at the churches in Portlock.

Local residents have described it as being a close-knit community in which each person knew everyone else. The kids had better behave themselves because if they did something wrong, their parents knew about it before they got home and dealt with the situation accordingly. People were out and about—they did not stay in their houses. They raised each other's kids. When something out of the ordinary took place—such as

an ambulance arriving—all the people came out of their houses to see what happened. Many of the residents were active in the local civic groups.

There were a number of amenities available to the citizens of Money Point. There was a post office serving Buell, Virginia. The local dance hall and nightclub served as main gathering places for the locals. There were two grocery stores located at opposite ends of Money Point. One was near the church at Robertson Boulevard and one was near Buell Street. The stores were owned and operated by the Costen brothers, Larry and George. Each store had originally been a two-story house. The first floor was converted to a business and the second floor was used for living quarters. The Money Point residents bought most of their groceries from these two stores.

The recreational opportunities included a centrally located baseball diamond where many of the children played and a trail for horseback riding. Also it was possible to board a boat on Buck Road or use a rowboat to cross the river to the community of Gilmerton, where a day of shopping or amusements could be enjoyed.

In 1894, the streetcars were electrified, enabling them to be propelled by means of a trolley and overhead wire. It was shortly after this that the streetcar ran the distance of the Berkley-Currituck Turnpike (Bainbridge Boulevard) to Freeman Avenue and then on to Money Point. There was a waiting room at the corner of Bainbridge Boulevard and Freeman Avenue. This was called the Portlock Station.

The streetcar ran until 1937 when the Portlock overpass over the Virginian Railroad on Bainbridge Boulevard was completed. After that the end of the line for the streetcar was at Holly Street in front of Lakeside Park. Passengers wishing to continue on to Portlock and Money Point were required to transfer to a bus.

For more than one hundred years the First Money Point Baptist Church has been the center of life in the community. Throughout that time the area residents have been active in church gatherings such as homecoming dinners, reunions and Vacation Bible School. The members and other local citizens showed their love for the church by donating their time, labor and gifts towards the church's reconstruction in the 1980s. Today this house of worship serves as a community anchor and a place of gathering for residents of Money Point and the Hampton Roads region.

Many residents of Money Point and the surrounding communities supported their families by working at one or more of the industrial plants at Money Point. Among the early industries were lumber, fertilizer, guano, lime and creosote. These were eventually joined by chemical, oil companies and cement plants. With all the different factories at Money Point there was a great increase in the number of trains in and out of the area. Many of them brought coal to the region. When the trains were overloaded with coal, some would fall off and land in between and beside the tracks. When times were hard, such as during the Great Depression, people would follow the trains, pick up these loose pieces of coal and use them to heat their homes or their cookstoves.

As the commercial and industrial center at Money Point grew, many of the residential sites disappeared in order to make way for new manufacturing or processing plants. Most of the homes along Buell Street were rentals, so when the landowners wanted to convert the land from residential to commercial use these people were forced to move. Little by little the rental property was bulldozed. A few of the homes were owner occupied and are still standing today.

South Norfolk

Prior to 1951, Portlock and Money Point were a part of Norfolk County and did not have city utilities. The people had lost their most reliable mode of transportation when the streetcars were replaced by buses. For one reason or another buses were not as reliable as the streetcars had been. Eventually Money Point transitioned to a more urban and industrial area as streetlights, industries and trucks replaced the local baseball diamond, stores and the dependable streetcar. As if this wasn't enough, hundreds of residents were displaced during the 1960s and 1970s in preparation for the construction of Interstate 464. This massive uprooting of people completely divided what was left of the community.

As mentioned before, Money Point served as an important industrial area and furnished employment for literally thousands of people; however, these jobs came with a high price tag. Each industrial plant contributed to the pollution that now plagues the Elizabeth River as well as the land near the river. Probably the largest single contribution came as the result of a fire at the Eppinger & Russell creosoting plant on Tuesday morning, September 10, 1963, at approximately 9:45 a.m. The eighty-five-year-old plant was the scene of a fire that was out of control for more than two hours. The flames were fueled by 130,000 gallons of creosote. Three or four explosions occurred, causing several tanks to split, and the heat melted others. The plant was three-quarters destroyed, and the estimated loss was $750,000 (a large sum of money at the time). Thousands of gallons of creosote ran into the river, adding to the already existing pollution. Four years later in 1967, another 20,000 gallons of creosote flowed into the river after a storage tank ruptured on property owned by Bernuth Lembcke Company.

Studies have shown high concentrations of polycyclic aromatic hydrocarbons (PAH), low biodiversity and high rates of liver cancer, lesions, deformity and cataracts in bottom-dwelling fish in this area of the river. Testing also indicates the presence of creosote in sediment and groundwater along with high levels of antimony, arsenic, cadmium, copper, mercury, lead, zinc and silver.

Short distances north of the industries at the end of Freeman Avenue were oil refineries. The Norfolk Terminal of the Texas Oil Company was located near South Hill in Portlock. Land along the Southern Branch of the Elizabeth River had been filled in 1910 and a plant for processing gasoline had been constructed. Texaco remained at that location for about ninety years. In its later years the plant processed lubricating oil. Other oil terminals nearby were Gulf and the American Oil Company.

The current shoreline facilities include oil and gas storage, salvage operations and concrete plants. Inland there are industrial and commercial facilities, along with a few homes in that area once known as Buell, Virginia. The roads have been in bad shape for a long time. This is caused by the large trucks that often travel over them.

Some of the present-day industries are planning major cleanups, such as underground bulkheads, to block creosote from escaping the site and flowing into the river. Others are addressing the idea of planting large groves of absorbent trees to soak up contaminants trapped in the ground. As for the river itself, among the options under consideration are dredging or capping the bottom sediment.

In the early days of the Elizabeth River Project, the area from Scuffletown Creek to the Jordan Bridge was designated as a test area. The idea was to see what it would take to clean up that section of the river, and if successful, proceed from there.

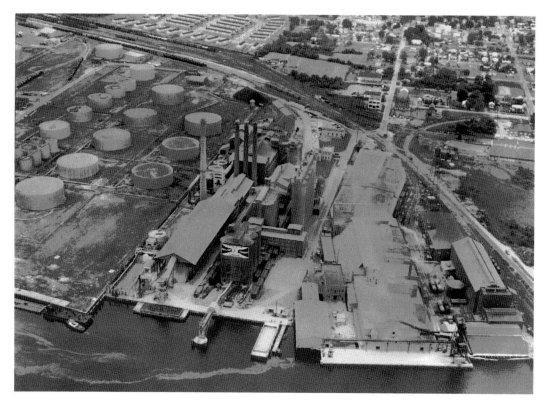

This aerial photo shows several of the industries on the South Norfolk waterfront. On the *lower right* is Royster Fertilizer, Lone Star Portland Cement is the plant in the *middle* and to its *left* is one of several oil companies that operated at the end of Ohio Street. In the *upper left* is the Admiral Road housing project. *From the author's collection.*

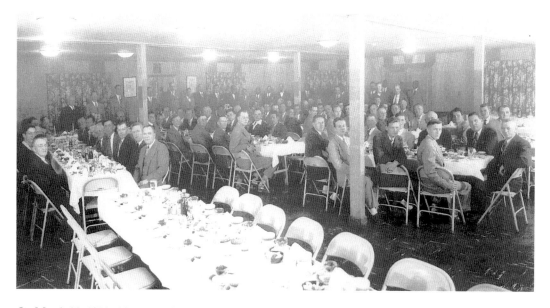

On March 20, 1951, this group of employees from the Norfolk terminal of the Texas Oil Company attended the safety award dinner at Carl Parker's Restaurant on Poindexter Street in South Norfolk. *Photo courtesy of Frankie Sweetwood.*

South Norfolk

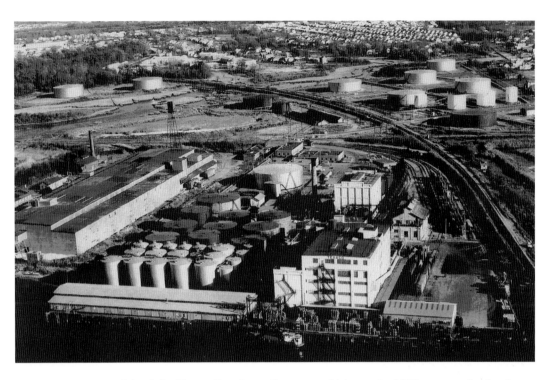

This aerial photograph is of the Texaco Petroleum Company, which acquired 139 acres on the South Norfolk waterfront and began operation on May 23, 1910. The plant closed around 2000. *Photo courtesy of Frankie Sweetwood.*

The cleanup of Money Point and the Elizabeth River is a monumental and certainly a worthwhile task that can only be accomplished by proper funding and a concerted effort by many concerned individuals. When completed, it will be another step toward the revitalization of South Norfolk and the salvaging of a very important area of the city of Chesapeake.

In addition to those industries in the Money Point area, there were oil companies and other large plants along the waterfront in South Norfolk. Before Interstate 464 was constructed there were several plants that could be reached by traveling the full length of Ohio Street. Lone Star Portland Cement and Royster's Fertilizer plants both were accessible from Ohio Street.

Public Health

The following information was provided mainly by Ms. Marilyn Shumaker at Lake Prince Center, Suffolk, Virginia, in October 2005, and Mrs. Linda Boyette, nursing supervisor, South Norfolk Health Center. Other sources include minutes of the South Norfolk school board meeting in November 1939 and also memories from my childhood. Wherever possible first and last names will be used; however, unlike fine wine, the human memory does not improve with age but has a tendency to fade ever so slightly.

Ms. Shumaker's career in public health began in 1944. She was very proud of the nurse's uniform and enjoyed wearing it. The summer uniform was white with blue pinstripes. In winter the nurses changed to a uniform of navy blue with a white collar, white gloves, navy blue coat and a military tri-white hat. The ladies always carried a navy blue bag, which contained the tools of their trade. Around 1985, the wearing of uniforms was discontinued.

In 1944, the Norfolk County Health Department was located on the second floor of a brick building at the corner of London Boulevard and Green Street in Portsmouth, Virginia. The first floor of the building was occupied by a restaurant that catered to "soul food." The smell of this food continuously filled the second-floor spaces.

At that time most other county offices and courts were also located in Portsmouth. The health department employed two nurses, a medical director and an environmentalist. Some time later they had two white nurses, two black nurses, two environmentalists and two administrative staff members. Many of the early employees received their training in the school of public health at the University of North Carolina. The first county health department in the state of Virginia was the one in Portsmouth at London Boulevard and Green Street, and the first city health department was in Richmond.

The primary duty of the early nurses was to visit the homes where communicable diseases had been reported. Diseases such as measles, mumps, whooping cough, scarlet fever, tuberculosis, poliomyelitis and others were considered a risk to the community, and households where those diseases existed were quarantined and a red sign was attached to the front of the house.

Early on it was thought that fresh air might be a cure for tuberculosis and many patients were sent to sanitariums, usually in mountainous areas. Patients were even required to sit outside in the cold of winter because it was believed that the cold air was beneficial towards the cure of diseases. Patients with poliomyelitis were sent to what was called a "contagious hospital" and some were confined to an "iron lung." Usually, if the family could not afford the required medical care, the local welfare department would assume that responsibility.

Dr. Mullen reported the first case of poliomyelitis in the city of South Norfolk to the welfare department (I believe the department was known as the Health and Welfare Department) on October 2, 1939. He had been contacted by Dr. Altizer and was asked to see the patient. Mrs. Frances Carter Bratten, superintendent of public welfare, notified Dr. Irvin L. Chapman, the health commissioner of South Norfolk. Dr. Chapman ordered the family quarantined and anyone else who had been in contact with the patient was also ordered quarantined. Mrs. Bratten then notified Mr. Myers, who was the sanitation officer for the city of South Norfolk, and he posted the required quarantine signs. In the early 1930s a Mr. Meginley held this job.

Mrs. Bratten also notified the public health nurse, Mrs. Edna McCaleb, who went to the house at 1406 Berkley Avenue. The child with poliomyelitis was ten-month-old Helen Creekmore. Arrangements had been made to put the child in the "contagious hospital." Other members of the family were Mr. and Mrs. Clifton Creekmore, Horace, age ten, and Raymond, who was three years old. Mrs. McCaleb explained the necessary precautions to be taken and the quarantine process to Mrs. Creekmore. In this case, there had been no outside contacts made so no other families were quarantined.

South Norfolk

Dr. Mullen reported the second case of poliomyelitis in South Norfolk to the welfare department on October 20, 1939. The patient was two-year-old Doris Bryant of 1210 Truxton Street. Dr. Chapman was notified and the family was quarantined. Family members were Mr. and Mrs. Arthur Bryant, Doris, Shirley, who was seven years old, and John William, age six. The Pierce family, who resided at 1312 Eighteenth Street, had visited the Bryant family and therefore was exposed. They were also quarantined.

Mrs. McCaleb visited these families on a continuing basis to check the other members, and Mr. Myers also visited with them to make sure that everyone was observing the rules of quarantine.

Care was taken by Public Health Nurse Edna McCaleb to check the pupils in the schoolrooms where the quarantined children had attended. Any child found to have a slight elevation in body temperature or a sore throat was sent home immediately.

Everything possible was done to prevent the spread of this disease. Ultimately the state began to send doctors to the different areas to hold orthopedic clinics for poliomyelitis patients. However, in order for a patient to attend it was necessary that permission be received from the primary physician.

The general public had become fearful of poliomyelitis. Crowded gatherings, as far as was possible, were avoided. Church and Sunday school attendance dropped off considerably, especially the children's classes.

Many of today's adults were victims of poliomyelitis and some were left with lifetime defects caused by that horrible disease. In the summer of 1944 one of my classmates died from poliomyelitis. I remember standing at the train station early in the morning as they loaded his body on the train for shipment to his hometown, where he was buried in the family cemetery.

In later years, thanks to the efforts of Dr. Jonas Salk, a vaccine was developed for the prevention of poliomyelitis. All children entering school were required to be inoculated with the Salk vaccine. Later the dosage was dispensed by dropping the medicine on a cube of sugar. Of course the children preferred it that way.

In the 1930s, when I was a student at South Norfolk Grammar School, typhoid shots were offered at the school in the spring of each year. For those whose parents decided that their kids needed to take them, a series of three injections, one per week for three weeks, were required every other year. Those shots were the most painful thing I ever experienced in my entire life. I would actually run from the teacher when she took the class to the clinic. Many students would cry for hours after receiving an injection.

In the earlier years the nurses filled the syringes and the doctors gave the injections. Nurses were not allowed to inject a patient. In 1925, Miss Elizabeth Davis was the public health nurse at the South Norfolk schools. She later married the Reverend Clyde Sawyer, pastor of the South Norfolk Baptist Church. In the 1930s, the school nurse was a Miss Tebault.

When restaurants became more plentiful, help was needed in the food service program, and Ms. Shumaker was transferred to that program. In addition to inspecting the restaurants, she also inspected barbershops and beauty parlors. Today, tattoo parlors have been added to that list.

The environmentalists were required to go on site and decide where septic tanks were to be installed. In making this decision it was necessary to draw a sketch of the desired location.

After installation it was also a part of their job to return, perform an inspection and make sure that the tank was properly covered.

During the earlier years of the health department, in-house clinics did not exist. This meant that the nurses were required to make many home visits in order to follow up on communicable diseases and other illnesses. Visits were also made in order to educate and check on the condition of new mothers. The nurses began each day with a full schedule of visits to be made. If they could find a telephone they would call the office during the course of the day. Restrooms were also hard to find, and often it was necessary for the nurses to request the use of a patient's facility.

Midwives delivered most children in the home. In the 1930s and 1940s there were a large number of them. On January 3, 1933, it was time for my mother to deliver. My brother and I were sent to fetch Ms. Daily, the midwife who lived about a mile away on B Street at the corner of Eighteenth Street in South Norfolk. We ran all the way there and back. At about 5:00 p.m. we were informed that we had another sister.

The nurses held monthly classes at the health department for this very large group of midwives. The gathering was always opened with the group singing old hymns and spirituals. This part of the gathering lasted for a long time as the midwives sang one hymn after another.

Early health directors were members of the Public Health Service. Later, the state appointed civilian directors. Some of these doctors had retired from the military and others did not want the stress associated with private practice or were seeking employment with regular working hours. For whatever reasons, these people preferred working for the health department. Most directors now have a secretary to schedule their daily appointments.

When inoculations were to be given at the public schools the nurse did the scheduling and went with the doctor. As stated before, the nurse was there to fill the syringes and assist the doctor who gave the shots.

Family planning services brought a lot of controversy. High school kids did not need parental consent in order to take advantage of services offered by the health department. After school, vans filled with high school age boys and girls would pull up in front of the clinic. The girls would go in and get birth control items. The clinic also offered tests for sexually transmitted diseases. Private doctors, who usually received honorariums of about five dollars from each patient, held most clinics.

Before 1963, there was one director for both districts of Norfolk and Princess Anne Counties. After the merger of South Norfolk and Norfolk County to form the city of Chesapeake and the merger between Virginia Beach and Princess Anne County to form the city of Virginia Beach, an additional director was hired and each new city had its own health director.

There is no longer a dental clinic, although one is needed. The space formerly occupied by the dental clinic is now an occupational therapy room. This program has a full-time doctor and staff. Operation Blessings recently made a visit locally with their van and were able to see a few dental patients.

When the health department left Portsmouth it was relocated to Cedar Road in Great Bridge near the Chesapeake Central Library. The building that housed the health

department faced Cedar Road. This was a time of great change. The nurses were even allowed to administer injections. The Chesapeake Health Center is now located at 748 North Battlefield Boulevard and the South Norfolk Health Center is located at 490 Liberty Street.

Chapter VII

Washington

Early Norfolk County courts were composed of about eight justices or commissioners appointed by the governor. These men fulfilled all the functions of local government—executive, legislative and judicial. At that time the county was divided into precincts for the purpose of law enforcement. After 1761, it was divided into three parishes for ecclesiastical purposes. After the Revolutionary War magisterial districts replaced the old precincts, and a board of supervisors elected from each district assumed the executive and legislative duties of the justices. One member of the board was chosen as chairman. The districts of Norfolk County were Tanner's Creek, Western Branch, Deep Creek, Pleasant Grove, Washington, Cradock and Butts Road.

The chief problem that each of the districts faced was the loss of county territory by annexation. Washington Magisterial District, as it was known at the time, suffered when the city of Norfolk annexed Berkley in 1906 and Campostella in 1923, and also when South Norfolk was established as a town in 1919. These three communities were part of Washington District.

Indian River and Oaklette

Early land grants along Indian River Road between present-day Campostella Road and Military Highway date to around 1650. There were no roads so these early settlers built their homes with extended wharves along the rivers where ships could deliver their needs and the farmers in turn could ship their products to nearby markets for sale. The most desirable mode of travel was by boat. The river was still clean, and there was an abundance of fish and oysters, which along with fresh produce from the farms made for many delightful dinners.

Eventually crude roads, which amounted to nothing more than dirt paths large enough to accommodate horse and wagon traffic and an occasional traveler on horseback, were built. These roads, however, usually amounted to mudholes in winter and dust bowls in summer.

In this distant photo we can see the bridge across the Indian River. The bridge is along Indian River Road in the Oaklette section of the Washington Borough. *Courtesy of Mary Lou Rock.*

The land in this section of the city of Chesapeake was earlier predominately woodlands and fields with farmhouses scattered along the banks of the Indian River—as was land in other sections nearby. It is not known exactly when the area known as Oaklette received its name. Approximately 121 acres of land bounded by the Indian River on the north and by farms on the east, west and south, is recorded as Oaklette in a deed transfer dated January 24, 1843. Mary Tatem inherited this land from her father, Nathaniel Tatem, in 1836. In 1843, she and her husband Thomas sold the land known as Oaklette to John Hope for the sum of twenty-one hundred dollars. Between 1843 and 1869, the land changed hands several times until Colonel William Etheridge sold it to Matthew Hare of New York. At that time, the deed still referred to the land as Oaklette.

The farms were still virtually isolated, with dirt paths connecting the fields of neighboring farms. Travel was by horse-and-buggy or wagon and the nearest main roads were Campostella and Providence. Campostella Road ran from Norfolk to Great Bridge. In 1729, this road between Norfolk and Great Bridge was the Post Road and later it became known as the Great Road. Providence Road, which earlier was called Chair Road, continued on to the area known as Kempsville. The Providence Christian Church was at the intersection of Campostella and Providence Roads. When inclement weather prevailed, the roads became very muddy, wagons usually got stuck and individuals found themselves in mud up to their knees. Oyster shells, when available, were used to cover the roads.

Indian River Road was one of those paths that were occasionally paved with shells from the oysters harvested out of the Indian River. This road became a main thoroughfare when the Indian River Turnpike and Toll Bridge Company was formed. The organization

purchased a forty-foot-wide strip of land between Steamboat Creek and Sparrow Road in 1878 and created the Indian River Turnpike around 1880. The designation as a turnpike did not mean that the road would necessarily be improved, but that a toll could be collected for use of the road. Joseph Paxson, the toll collector, wrote in 1904 and 1905 that the road was in such poor condition that people were refusing to pay the toll. The Turnpike Company went into receivership, and the courts condemned the turnpike as unfit for the collection of tolls.

In the early 1900s, Indian River and most of the surrounding communities experienced a considerable amount of growth. Nearby Berkley and the areas all along the Southern Branch of the Elizabeth River were becoming filled with a variety of industries. By 1902, a few homes in the Oaklette section of Indian River were beginning to be wired for telephones by Southern Bell. In 1904, the Suburban Railroad Company laid tracks from Campostella Heights up to and down Webster Avenue and up Oaklette Avenue to Indian River Turnpike at the bridge. The residents were now able to travel between Norfolk and Oaklette by electric trolley.

With the coming of trolleys, a new bridge was necessary to accommodate the tracks as well as foot and wagon traffic. On Thursday, November 10, 1904, the first pilings were driven. A new steel draw for the bridge arrived by barge in January 1905, and the new bridge was ready to receive traffic on March 20, 1905. Workers then began to remove part of the old draw and bridge so they could swing the new draw around. The first trolley, number eight, crossed the new bridge on March 22, 1905, at 3:15 p.m.

The Oaklette Methodist Church Community Center was probably built between 1884 and 1889 and was located between the church and parsonage. This building was used by the community as well as the church for socials and meetings. The Oaklette School, which was opened in 1900, used this one-room structure and became known as School Number Eight in the Norfolk County School District. It remained there until 1912, when the Norfolk Highlands School was built.

In 1920, a teacher earned $87.50 a month, and for that sum, she was required to teach two grades and perform other duties at the school. Female teachers could not be married, and those from out of town received room and board from local families. The marriage rule was relaxed during World War II, but was enforced again when the war ended. Each school year began with a new bottle of ink for the inkwell, which was a hole cut in the top of each desk. Students in the lower grades learned to write by practicing ovals and push-pulls in their Locker writing books.

Before schools had cafeterias, children brought their lunches in paper bags or lunch pails. Those who lived within walking distance went home for lunch. When arriving early or during recess, the children played games in the schoolyard. A hand bell was rung several times a day to signal the beginning and ending of the school day, recess, lunch break and other times as needed. The early classrooms were heated by potbellied stoves. Later, all local schools were heated by coal furnaces, which were located on the ground floor.

The students attended the Norfolk Highlands School until they completed the seventh grade. There were no high schools nearby until 1906 when one was established in South Norfolk, and in 1907 when Great Bridge opened its first high school. In 1922, a high

A History of Chesapeake, Virginia

The original Oaklette Chapel is seen here as it appeared on October 2, 1934. A close look at the sign reveals that John Banks was the pastor when this picture was taken. *Courtesy of Sargeant Memorial Room, Norfolk Public Library, Norfolk, Virgina.*

school was built in Portlock and the students from Norfolk Highlands then rode the bus to the Portlock School, where they could graduate after completion of the eleventh grade. A twelfth grade was added in the South Norfolk School in 1946.

The Norfolk Highlands School has received several renovations throughout the years and has come a long way from the one-room building of 1900. The main entrance has been changed from Lilac Avenue to Myrtle Avenue, and the school building has been doubled in size.

The Colonna Estate

Another place of interest in the Oaklette section was the estate of W.W. Colonna Sr. As the story begins we find Captain Will Colonna Sr., president of Colonna's Shipyard in Berkley, paddling his canoe three miles east up the Elizabeth River where he came upon

Washington

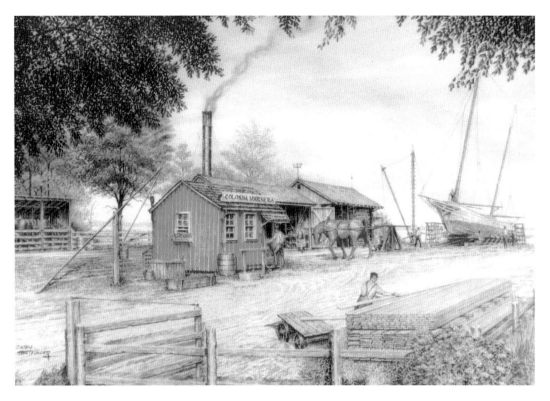

Charles J. Colonna built this small shipyard in 1875 near the confluence of the Eastern and Southern Branches of the Elizabeth River. This family business is now more than 130 years old. This painting by Casey Holtzinger is based on information from shipyard archives and from the accounts of Colonna family members. *Courtesy of W.W. Colonna Jr.*

the most beautiful point of land that he had ever seen. He could not get that wonderful picture out of his mind. The next day, he decided to try to find the owner and ask him if he would consider selling it. This time Colonna drove his automobile over the bumpy road from the shipyard to the Oaklette section of Norfolk County, where he made inquiries until he found the owner, who was Mr. Russell Hare. When approached Hare said he would sell, but he made it very clear that he would sell the entire twenty-acre farm and not just what he considered to be the good farmland, leaving him with that "no good point of land on the water" where the wind always blew the crops down. Captain Colonna, as he was sometimes called, agreed and bought the farm, including that "no good point of land on the water" for ten thousand dollars. The land included a house on the point in what was to become known as the "little circle." The house somehow involved a doctor and was said to be a house for nervous people. The family lived in this house while the mansion was under construction. After the new house was completed, the residence on the point was rolled on pine logs to its new location at 935 Lawrence Drive.

At that time the roads from the shipyard were unpaved and almost unusable, even in dry weather. To help solve the transportation problem, Mr. Colonna used his speedboat to travel to and from work.

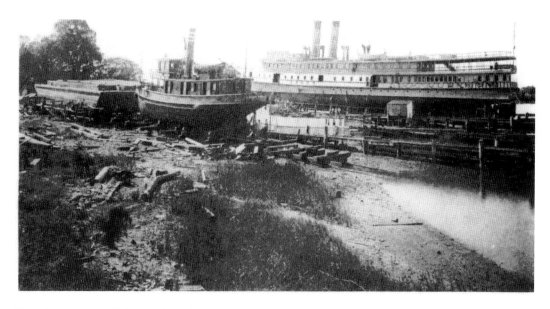

This photograph of Colonna Marine Railway Corporation in Berkley is dated circa 1910. *Courtesy of Sargeant Memorial Room, Norfolk Public Library, Norfolk, Virginia.*

 The cornerstone for the new house was laid in 1920 and completion took one year. It was a large, wood-frame structure standing two full stories with a finished attic and dormers making it appear to be three stories. There was a sun deck on the roof. The exterior weatherboards were made of gray cypress shipped from Florida and painted an off-white. There were forty-eight rooms and ten fireplaces in the house. It had two identical large porches, one facing the Indian River and one facing south, which served as the main entrance. The house was equipped with a below-ground basement where a large coal-fired furnace supplied hot water for domestic needs and also for the cast-iron radiator heating system that was used throughout the house. A dumbwaiter took supplies from the basement to the two floors above with an occasional child catching a ride. The cost of the house was $126,000, with $78,000 worth of furniture. All the furniture was Chippendale.

 Access to the house was through large, brick columns and down a lane with light posts leading to and around a big circle to the main entrance. On the approach to the main entrance, but several hundred feet away and nestled among the pine trees, was a steel water tower, which stood seventy-two feet high. This, along with a deep well and an electric pump, furnished water to the main house, the guesthouse, the home of the caretaker and all the other locations on the property that required water.

 The caretaker's home was on the left, or west side, of the property between the lane and the water tower. It was a one-story, white, wood-frame structure with a garage and workshop to the right.

 Rocks that had been used as ballast from the old sailing vessels were used to construct a walk around the water's edge, a rock garden and a house. A pond was built off the back of the rock house; its purpose was to contain the water from the river. The pond was large

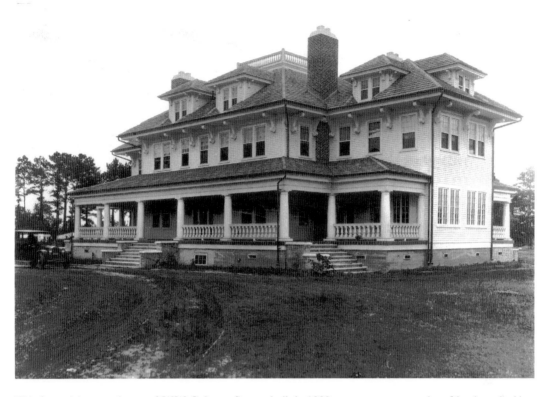

This forty-eight room home of W.W. Colonna Sr. was built in 1920 on a twenty-acre point of land overlooking the Indian River. The cost was $126,000. Fire was set to the house in 1923 and again in 1925. In 1925, it burned to the ground and was not rebuilt. *Photo courtesy of W.W. Colonna Jr.*

enough that it held five wooden rowboats—one for each girl in the family—and each boat, which was eight feet in length, was also personalized. The walk continued around the point where there were several sets of steps, some of which were covered with rose trellises and contained flowerpots made of rocks at the entrances. There were wooden seats built around some of the large trees and swings for the children. A pigeon house was perched near the top of a tall tree.

The walk came to an end on the east side of the estate where a huge wire enclosure had been built and was the home of all kinds and sizes of birds, both native and imported.

There was a boat pier at the end of the property where Colonna kept his yacht, which he named *Margaret* for his mother. The boat was of such size and complexity that it required an engineer when underway.

A tall flagpole stood at the end of the point, where the American flag was always flown. The concrete foundation contained the footprints of four of Colonna's daughters. Midway

on the property was a guest apartment with a car garage underneath and a rose-covered trellis dance hall off the back. There was also a very big stone basket in front where flowers were planted in such a manner that it appeared as a basket of flowers. On the east side of the property and several hundred feet from the bird cage was a dollhouse with miniature furniture. This is where the girls spent a lot of time playing house.

In addition to all the trees on the property when Mr. Colonna bought it, there were 101 pecan trees that he purchased through the mail from the state of Georgia. These he planted throughout the property, and almost every fall there was a large harvest of nuts, which the children picked up from the ground.

The mansion was typical of that era when many large homes were built. Taxes were few and people were able to keep most of their hard-earned money. Only the very rich made enough money to pay any taxes at all. I remember when I was in grammar school there were about thirty-five children in my class and only one of the fathers made enough money to pay income taxes. Just after World War I, the expression was "let the good times roll." This was a period of national prosperity and there was no reason to believe that it would ever come to an end—until the stock market crashed in 1929 and the Great Depression set in. The expression then changed to: "Mister, can you spare a dime?" I remember people standing on street corners trying to sell apples in order to buy shoes for their children. Incidentally, a pair of shoes could be purchased for the large sum of ninety-eight cents.

The new house burned twice. The first time was in 1923 when it was partially burned. After this it was rebuilt, but with a flat roof. It has been said that it never looked the same after that. The second time it burned was on a cold winter night in 1925 while the family was in downtown Norfolk attending a silent movie. Someone called the fire department but unfortunately the Indian River was frozen and at low tide. In those days the fire department depended on water suctioned from the river, and because of the existing conditions there was no water available to fight the fire. The house was totally destroyed. Captain Colonna always said that both fires were deliberately set and that he knew who did it, but there was no way of proving it.

As the house burned, the Colonna children remembered that the family cat had been left inside while they were away. That night, along with the great sorrow of seeing their beautiful home destroyed, their thoughts turned to the loss of the family pet. Bright and early the next morning, the cat was found wandering around the smoldering ashes. Their pet was totally unharmed. The family always believed that when the arsonist went in to start the fire, either the cat came out or was put outside by the person or persons that started the blaze.

There was little insurance on the house. In those days, most people carried very little or no insurance on their homes. After the second fire the house was never rebuilt. However, the property still remains in the family to this day and some new things have been added. One addition is a substantial log cabin down near the river.

In 1927, Captain Colonna, with the assistance of his daughters, built a houseboat on an existing Chesapeake & Ohio wooden railroad pontoon, which dated back to the 1800s. The houseboat was to be used as a hunting lodge. Each year in the late 1920s and early 1930s, the lodge was towed by tugboat to Mill Tail Creek, Buffalo City, North Carolina.

It was there that friends and associates hunted deer, bear and squirrel and counted the number of liquor stills in the East Lake area.

In 1935, the houseboat was anchored in the Indian River when a violent hurricane broke the boat's anchor cable and blew it up the creek. Captain Colonna built a series of dams and ponds and attempted to float the boat back to the river. After doing this several times and moving the boat a few hundred feet closer to the river, he abandoned the idea. It now remains in a freshwater pond behind the last dam built by Mr. Colonna. Today the houseboat is used for small socials, with family, friends, clubs and business associates. The interior is a mixture of nautical and 1920s furnishings. It even has its own player piano with lots of tunes from the early 1900s. There is one requirement upon entering the houseboat: you are expected to sign the guest register. The pond in which the houseboat sits is home to some very large turtles. Some of them are probably older than I am.

After the second fire in 1925, Captain Will Colonna and his family lived at his lodge in Blackwater, which was in old Princess Anne County on Blackwater Creek. They eventually move back to Oaklette and lived at 831 Saint Lawrence Drive in what is now Chesapeake. Captain Colonna spent the rest of his ninety-four years there. He often said near his death that had he not smoked he would have lived to be a hundred years old. Captain Willoughby Warren Colonna Sr. died Friday morning January 7, 1977, and was laid to rest in Forest Lawn Cemetery in Norfolk. He was born, lived, worked and died along a three-mile section from Colonna's Shipyard in the Berkley section of Norfolk, Virginia, to his home in the Oaklette section of Chesapeake, Virginia.

The Indian River area of Norfolk County consisted of numerous farms, and in its long and colorful history there were many outstanding families. I wish I could include all of them but due to space limitation I will mention just a couple.

As a result of the head-right system and a considerable amount of hard work, some of the early families became wealthy and were able to build large, well-landscaped homes that contributed to the social life of the surrounding community. The Murray family was one of those wealthy landowners that settled along the shores of the Elizabeth River. As a reward for sponsoring six persons into the colony, David Murray was granted three hundred acres of land along the Eastern Branch of the Elizabeth River. In 1777, Richard Murray willed to his only son Isaac his plantation and the tract of land on which it sits. Richard had inherited it from his grandfather David Murray and had added to the land by purchasing adjacent acreage.

Isaac Murray and his wife Frances Sparrow had a daughter by the name of Elizabeth. Elizabeth Murray was the first wife of William Nathaniel Halstead. They were married by Reverend George W. Nolley on November 24, 1830, in Princess Anne County. It appears that Isaac and Elizabeth had nine children, one of whom was George Nolley Halstead who became a well-known Norfolk County physician.

Another prominent and wealthy planter in this part of Norfolk County was Frederick Matt Halstead. He was born June 30, 1846, and entered the Virginia Military Institute (VMI) August 30, 1860, at the age of fourteen, where he studied under Thomas (Stonewall) Jackson. According to information from the Virginia Military Institute archives, Halstead resigned July 4, 1863, with deficiencies in math, Latin and French. The same month he

This modern painting by Casey Holtzingser portrays a typical farmhouse of the late eighteenth century. It was located on the Indian River and was built mostly of hand-hewn heart pine timbers fastened with wooden pegs and hand nails. *Courtesy of W.W. Colonna Jr.*

enlisted as a private in Company B Sixty-eighth North Carolina Regiment CSA. On January 1, 1864, he became a first lieutenant and on August 7, 1864, he was promoted to the rank of captain.

After the war Fred Matt Halstead became a farmer in Norfolk County and later became president of Tidewater Quarry Company. He lived in his ancestral home at Indian Grove on the Indian River, two miles east of Norfolk, Virginia. This land was part of the original land grant of Henry Halstead in 1650 or 1651. Fred Matt Halstead probably never married. He died on October 8, 1924, and was buried in the Halstead (Holstead) family cemetery. Having been a man of financial means, local churches and others often approached him for assistance. After his death, rumors that he had been buried with money and other valuables led grave robbers to open his casket several times, and they removed his Civil War sword, gold teeth and diamond stickpin. I have heard several different stories about his skull being removed and placed in an attic. I hope they are just stories.

The Village of Berkley

Prior to January 1, 1906, Berkley was a part of Washington District. Even today some families can trace their roots to the old village at that point where the Eastern and Southern Branches of the Elizabeth River meet. Before becoming Berkley, however, it was known as Herbertsville, Powder Point, Washington and then Ferry Point.

It was once a prosperous community with lumber mills, box factories, shipyards, financial institutions, a college, waterworks, Garrett's Winery, knitting mills and an assortment of other businesses. Prohibition put the winery out of business and dwindling forest caused the box factories and lumber mills to leave. To add insult to injury, on April 13, 1922, more than a third of Berkley was destroyed by fire.

In most early communities, churches were considered a necessity and Berkley was no different. The nearest church was Saint Paul Episcopal in Norfolk. (Remember, it is the one with the cannonball lodged in the southeast corner of the church.)

The first residents of Berkley, in order to attend church services, had no choice but to row boats across the Elizabeth River and join the parishioners at Saint Paul Episcopal Church. That wasn't too bad when the weather cooperated; however, especially in winter when parts of the river froze over, the trip could become treacherous.

Around 1910, the Norfolk Haberdashery Company and Tailors were located on Berkley Avenue. Until 1906, Berkley was a part of what is now the Washington Borough of the city of Chesapeake. *Courtesy of Sargeant Memorial Room, Norfolk Public Library, Norfolk, Virginia.*

At that time the Reverend Robert Gatewood was assistant pastor at Saint Paul Episcopal Church on Church Street in Norfolk. It was through his efforts that a mission of Saint Paul was organized in Berkley. For several years before a church could be built, services were held in the former courthouse at the corner of Walnut and Pine Streets. It was the custom prior to 1870 for the Methodists and Episcopalians to hold services in the courthouse alternately twice a month. The combined membership of both denominations participated in the Episcopal services and likewise the Methodist services two Sundays in the month. These services continued for many years until the courthouse no longer could accommodate the number of worshippers of the two denominations and each membership was large enough to warrant the construction of its own separate church building.

In 1872 Lycurgus Berkley, for whom the town was named, donated sites as well as financial assistants to build churches for both congregations. The Episcopal Church was completed in February 1872, and was consecrated by Bishop Whittle on April 13 of the same year. The mission continued to grow, and in a few years it was recognized by the council of the diocese of Virginia as a parish separate from the mother church in Norfolk.

Dr. Robert Gatewood, who had served as a chaplain in the army of the Confederate States of America, continued as its pastor. His home was behind Saint Paul Episcopal Church in Berkley and he operated a school in a building beside his house. Gatewood died in 1909 and was buried in Elmwood Cemetery in Norfolk, Virginia. One of the elementary schools in Berkley was given the name Robert Gatewood.

In 1911 the Episcopals built another church in Berkley at the southwest intersection of Dinwiddie Street and Poplar Avenue. At that time the name was changed to Saint Brides. They remained at this location until 1960. Upon leaving Berkley they built a new church at 621 Sparrow Road in the Washington District.

What happened to the Methodist congregation? They built their first church on Chestnut Street. After outgrowing that building they built a large stone church at the corner of Berkley Avenue and Dinwiddie Street. It was then that the name was changed from Chestnut Street Methodist Episcopal Church, South to Memorial Methodist Church. A few years later they sold the building in Berkley and built a new one at 804 Gammon Road in Virginia Beach. There were eventually many other churches in Berkley. Some of the original buildings still stand.

The Chesapeake Arboretum— Nature's Classroom

The land now being utilized by the Chesapeake Arboretum was first settled by members of the Carson family around 1630. They struggled with the land until about 1670 when the house was destroyed by fire. Rather than rebuild, the Carsons decided to leave the hard country life and move back to Norfolk where life was considered to be slightly more civilized. The land, which consisted of two thousand acres, remained unattended until approximately 1730 when ownership was granted to the Williamson family.

In 1995, Carol Williamson Marks donated the house and forty-eight acres of land to the city of Chesapeake for an arboretum. Looking south from the house is a line of cedar trees

that leads to the Williamson family cemetery at the edge of the property. This is the final resting place of Caleb Williamson and his wife Martha McCoy Williamson.

What is now the west end of the farmhouse was constructed around 1730. The house then consisted of a living room and dining room on the first floor, and upstairs there was one bedroom for the family. By 1822, the east end had been added to the farmhouse. This addition included a sewing room downstairs where clothes for the family were made and where clothing in need of repairs was mended. Another bedroom, along with a nursery, was added upstairs. It wasn't until 1940 that an inside bath became a part of the upstairs living space.

As was the custom in early America, the kitchen was built separate from the main living quarters and was located out back where the small barn is today. The main reason for this separation was because food was prepared over an open flame and quite a few fires originated in the kitchen, sometimes leading to total destruction of the building.

The Williamson's smokehouse was located where several fig trees now stand. In January 1996 it was discovered that termites had caused irreparable damage and the small building was torn down. Eventually, when funds become available, a new smokehouse will be built.

This eighteenth-century structure, which is known as the Caleb Williamson Farmhouse, is located at 624 Oak Grove Road in Chesapeake and is decorated in the style most used in 1860. In 1997, Ms. Kate Etheridge and her sister donated one of the three Williamson family Bibles and two family quilts to the Chesapeake Arboretum. One of the quilts was made by

The Williamson farmhouse, which was constructed around 1730, now serves as the headquarters building for the Chesapeake Arboretum. *From the author's collection.*

their grandmother, Ludie, and the other by their great-grandmother. The Etheridge sisters also donated a Civil War–era photograph of Robert Carson and Major William Etheridge. According to the Williamson family Bible, the Reverend N.B. Foushu joined Carroll M. Williamson and Ludie Etheridge in holy matrimony at Oak Grove on December 18, 1901. They lived in the Williamson house for a number of years. The home is in phase three of a five-phase reconstruction plan. Replacement of the siding is a part of that plan.

The Chesapeake Arboretum is a forty-eight-acre natural classroom dedicated to promoting horticultural and environmental awareness through displays, education and research. The arboretum was dedicated in November 1996. Across the street from the farmhouse is one of the finest systems of trails in the state of Virginia. They meander through approximately three miles of hardwood forest. Mature trees, some as many as two hundred years old, are marked with signs to correspond with identification on the trail map, which is made available to all visitors. Wooden bridges cross a clear stream and benches offer spots to rest and view reptiles, numerous butterflies and the various kinds of birds that make their home on the property.

Upon visiting the arboretum, one will find many trees on the property—and almost as many stories as there are trees. As one story goes, in colonial times trees were planted in such a manner that they formed a road or path that led to places of importance. For instance, to the west of the arboretum house there is a grove of pecan trees in two parallel lines. They pass between the two barns on the property. Most likely they led the way to the fields where the crops were planted. Looking to the south there is a line of cedar trees leading to the Williamson family cemetery. From the cemetery there is a line of cedar trees that leads to the Oak Grove Church.

Occasionally the well would run dry and a new one had to be dug. When this happened, the old well was filled with dishes, clothes, furniture and other household items that were no longer of use. The idea was to fill the abandoned well in order to keep someone from falling in. Today, as a safety precaution, there is a law that wells no longer in use must be filled with rocks and cement.

In construction of colonial homes, orientation of the house was very important. They were usually positioned as to allow for natural cooling and heating. Cooling was accomplished by placing the house so that prevailing winds could blow through and circulate by opening key windows and doors in summer. Evergreen trees were located on the north side of the house to minimize the cold northern winds in winter. Trees that shed their leaves in the fall were planted on the southern side of the house in order to take advantage of the sun in winter.

Traditional belief is that when a Native American chief died, an oak tree was planted beside his grave. Each chief had a different type of oak planted in order that a historical record of the tribe could be maintained simply by observing the size and type of oak. If this is true then the Oak Grove section of the city of Chesapeake was a sacred burial ground of local American Indian chiefs. This may explain why Native American artifacts have been found in this area.

The Williamson farmhouse serves as the arboretum headquarters building and is surrounded by a variety of gardens. Throughout the year special programs are offered to

promote public awareness of the various kinds of trees, plants and shrubbery. In addition to these programs, many other events and parties are also held on the grounds. The members are proud of their environmental and outstanding service awards. The Chesapeake Arboretum is nonprofit and is dependent upon donations, contributions, membership dues and volunteer services.

Greenbrier

At the time of this writing the Commonwealth of Virginia was celebrating its four-hundredth anniversary. However, the story of Greenbrier has its beginning in the year 1907 when Virginia was celebrating the three-hundredth anniversary of the settlement at Jamestown. The Jamestown Exposition, which had been in the planning stage since 1900, had its formal opening on April 26, 1907.

One of the attendees was Robert Earl Thrasher, who was commissioner of transportation for the state of West Virginia. One of his duties was to oversee the shipment of coal that was dug out of the mountains of West Virginia. Thrasher had two reasons for coming to Norfolk at this time. One was to arrange the shipment of coal to Norfolk and its distribution from Norfolk to other ports. The other reason was to attend the Jamestown Exposition.

After leaving Norfolk, he continued his business trip by traveling to North Carolina and then to South Carolina. After completing his business, Mr. Thrasher began his train trip back home to Greenbrier County, West Virginia. The first leg of his journey was by way of the Norfolk and Southern Railway, which took him to Union Station in Norfolk. Here he boarded a Norfolk and Western train, which carried him to West Virginia. While looking out the train windows he noticed the grass and soil of Norfolk County and thought to himself that the soil looked very rich and would probably make good farmland.

Sometime later, after arriving home, Mr. Thrasher began to think about the beautiful, rich land that he had seen in Norfolk County. Around 1914, Thrasher felt that the time was right and he decided to make a move. At that time Frank L. Portlock Sr. held the position of demonstration agricultural agent for Norfolk County. Just how Mr. Thrasher knew about Mr. Portlock is not clear, but contact was made between the two men and Mr. Portlock found several property owners who were willing to sell their land in Norfolk County. Thrasher made a trip to meet with the landowners and purchased twenty-two hundred acres at twenty dollars per acre.

He returned home, resigned his position and moved his wife and seven sons to Norfolk County, Virginia. The sons were Roscoe, Allen, Guy, Irvin, Samuel, Dave and Thomas. The land he purchased was a swamp, but with the expenditure of countless hours of labor by a man with a dream, it became a thing of beauty and symmetry. One son established a dairy farm, another raised pigs, another started a chicken farm and a fourth son went into sheep farming.

Unfortunately Buck Trout Swamp ran through the center of the Thrasher property, and living in the swamp were many wild animals such as coyotes and wildcats. The flock of sheep began to decrease and it was soon learned that the wild animals were killing

them. The Thrashers then decided that sheep farming was not going to be profitable and discontinued that farming project.

It was around this time that Mr. Thrasher met a man from upstate New York who was in the nursery business. This man felt that the Thrasher property would be suitable for raising fruit trees and if Mr. Thrasher was interested, he would ship him a couple thousand seedlings consisting of apples and peaches. Mr. Thrasher agreed to plant the trees and monitor their growth. An agreement was made between the two men and the trees were planted. Two years passed and the trees grew to such an extent that Mr. Thrasher decided to go into the nursery business and give it the name Greenbrier after his former home county in West Virginia. The family had purchased additional land and now owned seven thousand acres. Other nursery stock was bought and sold and eventually the business became known as Greenbrier Nursery Products, the largest nursery in the world.

What in the beginning was a swamp of muck and slime later became a nursery farm occupied by an abundance of beautiful shrubs, flowers and plant life. More than five thousand varieties of plant life, ranging from the hardy oak to the delicate camellia, were grown there. There were numerous hothouses for more fragile plants. The constant experimentation that was carried on at the nursery resulted in newer and sometimes more hardy plants and trees. Each group of plants was catalogued, making it easier to locate a particular one when needed. Greenbrier served the local customer as well as customers throughout the world.

All went well until 1929 when the Great Depression brought the country to its knees. There wasn't much money in circulation and as a result the nursery was not getting many orders for its stock. The family business fell on hard times. It was around this time that Robert Earl Thrasher died. Business continued to fall off and eventually the world's largest nursery went out of business. The family decided to sell the land. However they bought a small acreage of land west of Battlefield Boulevard, down Sign Pine Road. Although the nursery is not as large as it was, it is still in business today.

In the 1970s, most of the land that had once been the world's largest nursery was sold and Greenbrier Parkway was built. Even today, when driving along the parkway, one can still see magnolias, a variety of cedars and other trees that were a part of the original Greenbrier Farms and Nursery.

Around 1980, land was acquired on Greenbrier Parkway and in 1981 the citizens of Chesapeake received their own local mall. Its name was, of course, Greenbrier Mall. Many truckloads of dirt were hauled in to create a huge mound on which the mall was built—thus the main entrance places the customer on the second level instead of the first.

One of the longtime tenants of the mall is Waldenbooks, which is now a part of Borders Group. Though not generally known by the many patrons of the store, this establishment has its own ghost, which has shown himself to several employees. It is not known if this spirit, which stands approximately six feet in height and appears in a white robe, frequents the other stores or shops or if he is just interested in reading. It seems he has nothing better to do than glide through the store, pull books off the shelves and laugh as they hit the floor. If you are a lover of books as I am, you just may meet him sometime.

The planned community of Greenbrier is home to many Chesapeake residents. It also has a large number of restaurants, other shopping centers, movie theaters and eighteen of the finest hotels and motels. There are also eight hotels in the Military Highway area and seven others are located in the borough of Western Branch.

When the city of Chesapeake turned twenty years old, a decision was made to celebrate, and it was in May 1983 that the first Chesapeake Jubilee was held. It began on Thursday, May 13, 1983, at 3:30 p.m. and closed on Sunday, May 15, 1983, at 7:00 p.m. The city had no park at that time and the first three jubilees were held on Greenbrier Mall property. After three years the mall finally set into motion its expansion plan, which took the land that had been used for the first three jubilees. The city then decided to find a site that could be bought. When city representatives went to Richmond and asked to purchase the land where the city park is today, they were refused. It was then that the search committee called for help from a very influential state senator. One week later the city bought the property for $857,500 with interest-free payments spread over a ten-year period. The site was ready when the jubilee was held May 16, 17 and 18, 1986. The twenty-fifth jubilee was May 18–20, 2007.

Crestwood

The community of Crestwood came into being during World War II when there was a severe shortage of housing. Oscar F. Smith of Smith-Douglas Fertilizer Company turned woodland near the plant into a housing development for some of his employees. Crestwood was built at the intersection of Southern Branch Boulevard and Great Bridge Road. In addition to housing, he built stores for shopping and a movie theater for entertainment. Eventually schools were also constructed at Crestwood.

After about sixty years, the old World War II housing was demolished in favor of beautiful two-story homes; however, the shopping area is no longer used and needs to be demolished.

A History of Chesapeake, Virginia

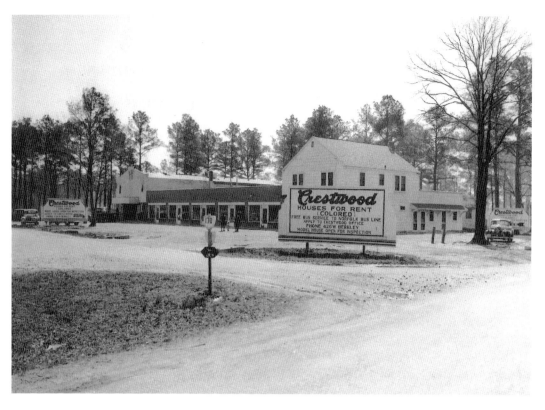

During World War II, there was a shortage of housing and Mr. Oscar Smith built the Crestwood housing development for employees of his fertilizer plant at the corner of Southern Branch Boulevard and Great Bridge Road. This intersection is now the corner of Great Bridge and Bainbridge Boulevards. *Courtesy of G. Paylor Spruill.*

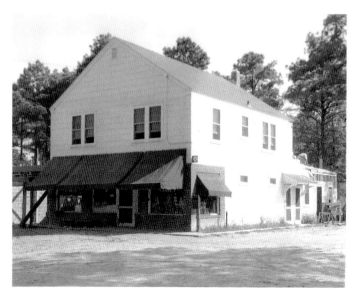

This is the Crestwood Market at the corner of what was then Great Bridge Road and Southern Branch Boulevard. The second floor provided living quarters for the manager. The small addition on the back of the building eventually became the project office. *Courtesy of G. Paylor Spruill.*

Washington

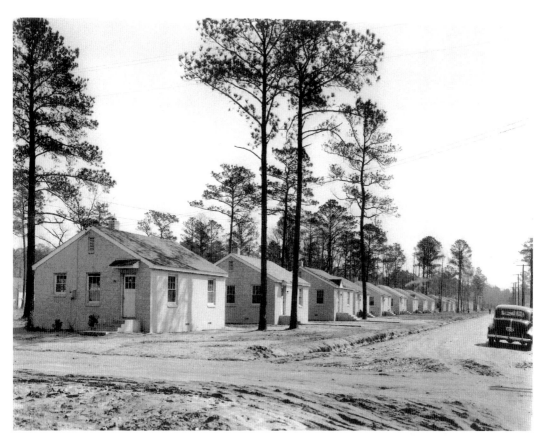

Before World War II this was a wooded area; however, in this photo, as far as the eye can see there are dozens of the small units that were a part of Crestwood. In recent years these houses were replaced with handsome two-story homes. *Courtesy of G. Paylor Spruill.*

Chapter VIII
Pleasant Grove

Pleasant Grove is one of the largest boroughs in the city of Chesapeake. You might say that the bridge at Great Bridge acts as a dividing line between the boroughs of Washington and Pleasant Grove.

The city complex, where most of the city's governmental actions take place, is located just a short distance from the bridge. It is here that the court building, community center, central library, planetarium, school administration building, the city hall and the Chesapeake Veteran Memorial are located.

In the southern part of Pleasant Grove we find the old and the new in homes, schools and churches. It is there that Hickory Ground, the Northwest Radio Station and the city water treatment plant are located.

The Chesapeake Library System

The library system consists of the Central Library at 298 Cedar Road, six area libraries and a bookmobile. The area libraries are Dr. Clarence V. Cuffey, Greenbrier, Indian River, Major Hillard, Russell Memorial and South Norfolk Memorial.

The Chesapeake Public Library Board serves as an advisory board to the city manager, the director of libraries and the city council concerning matters relating to the conduct, improvement and support of the Chesapeake Public Library.

The libraries are educational support centers in that they provide reference materials as well as computer services. They also have a large collection of recently published novels for the reading enjoyment of citizens of all ages. The Wallace Room at the Central Library serves as a reference center for genealogical and local history information. There is also a Public Law Library on the second floor. All the libraries are equipped with videos, magazines, newspapers and CDs. There are meeting rooms available at each location, which can be used free of charge by nonprofit and civic organizations. The system offers reading and other programs for both children and adults.

The lady in this 1919 photo is Mrs. W.C. French and she seems to be exploring the surroundings of the old bridge at Great Bridge. *Courtesy of Stuart Smith.*

The central library can be seen in the upper left of this view of the Chesapeake municipal center. The large building near the upper left center is the back of the city hall. The street near the center is Albemarle Drive where the public safety and city jail are located. *From the author's collection.*

Pleasant Grove

This circa 1974 aerial photo of the Hickory Ground School was taken by Earl Updegraff. The small specks, *left of center*, were Ms. Myrtle Lambert's fourth-grade students reenacting the War of 1812. *Photo courtesy of Myrtle Lambert.*

Ms. Myrtle Lambert, fourth-grade teacher at Hickory Elementary School, posed with several students to have their picture taken on the front steps of the Hickory United Methodist Church, circa 1972. *Photo courtesy of Ms. Myrtle Lambert.*

A History of Chesapeake, Virginia

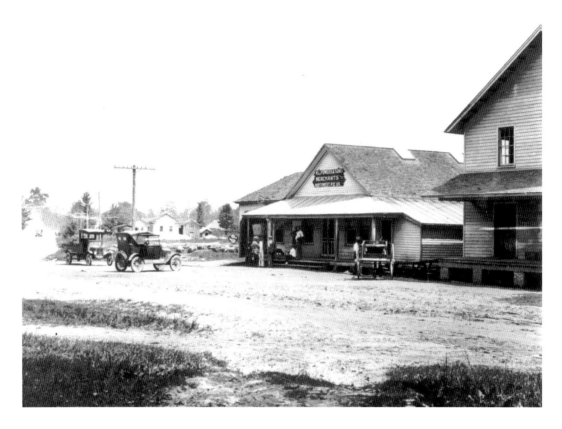

The W.L. Powers and Sons General Store and the Northwest Post Office were located on this dusty road in the 1920s. *From the author's collection.*

The Friends of the Library holds book sales and is involved in other activities to help the library system financially. Rooms such as the Wallace Room at the Central Library and the Linwood L. Briggs Literacy Room at the South Norfolk Library were made possible by donations from those families. Several special events are held at the libraries each year.

Public Safety

Public safety for all citizens began when the first legislative body in America met in a small church at Jamestown one hour before sunrise on July 30, 1619. The meeting, which was called to order by Governor George Yeardley, consisted of members of his council, the Reverend Richard Buck and representatives of the two precincts in existence at that time.

Prior to the year 1634, Virginia had no uniform county system or organization. By 1634, the spread of the plantations away from Jamestown made it necessary to institute a system of local government. It was then that the colony was divided into eight shires or

counties. Each of these counties had its own court of records presided over by a bench of justices who were known as county commissioners. Each county had a sheriff and a clerk of the court. In 1634, the bounds of Elizabeth City County included what would become Norfolk and Princess Anne Counties and also a part of Nansemond. It is believed that a new county known as New Norfolk was formed in 1636 from land extending south of the James River and Hampton Roads. It is certain that two counties were organized in 1637. One was known as Upper Norfolk and included the bounds of Nansemond County. The second was given the name Lower Norfolk County.

Adam Thoroughgood convinced the General Assembly to create a new county, and as a result he was appointed presiding justice over the court. Thoroughgood was born in 1604 and was the seventh son of an English vicar. He arrived in Virginia in 1621 as an indentured servant of Edward Waters. He completed his indenture in 1625 and received his first land grant the same year. Two years later he returned to England and married Sarah Offley, the daughter of a wealthy London merchant. Adam and Sarah left England and took up residence in Virginia.

The first recorded court session in the new country was held at Adam Thoroughgood's house at Lynnhaven on May 15, 1637. Two cases were tried that first day. The first was that of Anne Fowler, who was accused of saying insulting words against—of all people—Adam Thoroughgood. She was found guilty, received twenty lashes and was required to attend the next service at the parish church to publicly confess her sin and apologize to Thoroughgood. The second case involved Bartholomew Haynes and Julia Underwood—"she being bigg with child." The punishment was a wedding between the two young people.

Sessions of the county court continued to be held monthly at various private homes. Usually the homes were located near rivers or creeks as most travel in those days was by water.

The first trial by jury held in Lower Norfolk County was between Richard Foster and John Gookin. Gookin's hogs got into Foster's cornfield and destroyed his crop. The jury returned a verdict in favor of Gookin because he had a hog pen and Foster's field was not fenced in.

In March 1654 the General Assembly authorized the county to create a port in each parish. The port or marketplace was to contain a court, church, tavern, ordinary and a variety of shops. By this time Lower Norfolk County had been divided into two parishes. A decision was made to establish one marketplace on the Elizabeth River on the land of William Shipp and another on the Lynnhaven River on land belonging to Adam Thoroughgood's widow and descendants. But before construction could begin, the General Assembly cancelled the legislation authorizing the marketplace. In January 1660 the justices decided to build a single courthouse on land acquired from Thomas Hardy. This piece of property was on Broad Creek.

While the courthouse was under construction, Thomas Hardy allowed the justices to hold court in his home. The courthouse was completed in the latter part of 1661. On September 17, 1689, members of the court reported that the structure on Broad Creek was in ruins and beyond repair. A decision was made to build two courthouses in the county. One was to be built on the Elizabeth River near Norfolk Towne and the other on land belonging to

Edward Cooper on the Lynnhaven River. Sessions were to be held in August, December and February at Lynnhaven, and in the other months at the Towne of Norfolk. This was to make the court available to all citizens.

In 1691, lower Norfolk County was divided into Norfolk and Princess Anne Counties. In the summer, work was begun on a new courthouse in Norfolk, and it was completed in 1694. In 1789, the legislature chose Powder Point as the location for the next Norfolk County courthouse. In 1801, the county courthouse was moved to Portsmouth, where it remained until 1963, when the city of Chesapeake was formed.

The records that were preserved in the office of the Norfolk County clerk in Portsmouth are now in the office of the clerk of the circuit court of the city of Chesapeake. Those records began on May 15, 1637, and have with few exceptions been kept up to the present time.

Before the merger between the city of South Norfolk and Norfolk County, the Norfolk County Board of Supervisors met monthly at the courthouse in Portsmouth. Before South Norfolk became a town in 1919, it had a supervisor that represented the village at each meeting. After becoming a township, South Norfolk's government consisted of a mayor, nine councilmen, a treasurer, a clerk of the common council and a town sergeant.

Throughout the years, hundreds of dollars have been appropriated by a variety of organizations to be used for restoration of old Norfolk County records. Among the contributors were the Norfolk County Board of Supervisors, the Norfolk-Tidewater Committee of Colonial Dames, the Fort Nelson Chapter of the National Society of the Daughters of the American Revolution and others.

Chesapeake Police Department

On Thursday, October 18, 1962, it was announced in *The Norfolk Virginian-Pilot* newspaper that Captain Wilbur E. Sears of the Norfolk County Police Department would become chief of police of the new city of Chesapeake. Sears served until 1969. Others that served in the position of chief of police are Albion B. Roane Jr., 1969; Roland A. Lakoski, 1971; Ian M. Shipley Jr., 1990; and Richard A. Justice, 1996 to the present.

The office of sheriff came into being around 1634 when the colony was divided into eight shires. Norfolk County has had at least two dozen sheriffs from 1634 through 1920. In 1944, Arthur Hodges became sheriff of Norfolk County and held the position until 1969 when he was replaced by John Newhart. Newhart has served as sheriff of the city of Chesapeake from 1969 to present.

Chesapeake Fire Department

Since the city of Chesapeake was formed in 1963, it has had four men serve as fire chief. The first was John Ben Gibson Sr. who was followed on January 1, 1970, by Robert G. Bagley. Bagley retired on July 1, 1986, and was replaced by Michael L. Bolac from the Alexandria Fire Department. After Bolac resigned, a nationwide search

Pleasant Grove

Here we see the old and the new. This night scene was taken in 1993 in front of the Chesapeake municipal building. The blue 1963 police car with the single red flashing light on top is the older of the two and now serves the department in local parades and exhibitions. *From the author's collection.*

for a new chief revealed that the most qualified man was already serving the city as assistant chief. There is a lot to be said for promoting from within. It saves tax dollars, boosts moral and usually allows for a more qualified man to be placed in the position. Assistant Chief R. Stephen Best, who began his career as a volunteer with the Deep Creek Department and became a paid firefighter in December 1974, received the job as Chesapeake fire chief.

City Hall

As the city of Chesapeake began to grow, it became necessary to build more and larger buildings to house the city's operations. On January 10, 1987, the groundbreaking ceremony for the new city hall was held. James Rein was city manager and Sidney M. Oman was mayor. The dedication took place on January 14, 1989. James Rein was still city manager,

but David I. Wynne was now mayor. Members of city council had appointed all previous mayors. Mayor Wynne was the first mayor to be elected by the citizens.

Since the merger became effective on January 1, 1963, ten members of council have served as mayor of the city of Chesapeake. They are as follows:

Colon Hall	1963
Howard R. McPherson	1963
Guerdon A. Treakle	1965
William S. Overton	1970
Marian P. Whitehurst	1972
Sidney M. Oman	1980
J. Bennie Jennings	1984
Sidney M. Oman	1986
David I. Wynne	1988
William E. Ward	1990
William E. Ward	1992
Dalton S. Edge	present

The Happer House (3162 Ballahack Road)

The Happer house was built in 1768 by Captain William Happer II, the youngest son of Dr. William Happer and his second wife Sarah. William Happer II inherited from his father what was known as the Upper Plantation. The land had been originally patented in 1691 by Captain Happer's maternal grandfather, William Heslett, who jointly with Edward Creekmore and Henry Dale owned two thousand acres there in 1694.

The house remained in the Happer family until 1869. It was then sold to Mr. William H. Newbern. The Newbern family remained on the property until 1950. When Mr. and Mrs. Madison "Mat" Riley bought the house in 1950, it had fallen into a state of partial ruin. After several months of research, restoration on the Happer house was begun. It took many thousands of dollars and two years of hard work to put the house in livable condition.

All the bricks in the house and chimneys are original and were made from clay dug on the property; however, they had to be repaired. Many of the windowpanes are also original. The walls are solid brick laid in Flemish bond and the interior plaster is applied directly on the brick. The walls are eighteen inches thick, permitting deep window seats. The window and door frames and outside doors had to be replaced, but are the exact dimensions as the originals. The house is of English Gambrel style with the pitch of the upper roof continuing over the dormer windows of the second floor. Shingles on the roof were replaced. There are twin chimneys on the west side of the house.

On the first floor, there are two large rooms and an entrance hall, which goes from the front of the house to the back. The old plaster was removed and new was installed throughout. The new plaster was then painted the original color.

Pleasant Grove

The Happer House was built in 1768 by Captain William Happer II. It sits halfway between what is today Ballahack Road and the Northwest River. This undated photograph shows the house as it probably was in 1869 when the family sold it. *Photo courtesy of Larry Floyd.*

There are two bedrooms with fireplaces on the second floor and there appears to have been two smaller bedrooms in the original house. When the Rileys modernized the home they installed a bathroom and closets on the second floor—one of the small bedrooms was used for that purpose. The full attic extends the entire length and width of the house. There is also a full basement with recesses in the two chimneys, but there are no fireplaces. There was a one-story wing on the west end of the house. Photographs of the backside of this wing show a porch, and it appears that this smaller structure had a tin roof. This small building was used as the kitchen. The smokehouse stood a few feet west of the kitchen. This one-story wing had deteriorated to the point that it could not be restored. The Rileys removed the old wing and built the present frame wing, which contains a kitchen, bathroom and library.

The area to the rear of the property is now filled with trees. The family burial ground, which is near the wooded area of the Happer house, sits halfway between Ballahack Road and the Northwest River. The river can no longer be seen from the house because of the trees. There are no tombstones. A short distance from the family graveyard is an area that is said to be the slave burial ground.

Local tradition has it that George Washington slept at the Happer house while surveying the Dismal Swamp Canal. This is most likely not true. The man may have spent the night at a number of different residences, but there is no way he could have slept in all the places in which he has been credited with sleeping. Another local legend is that in 1803 Thomas Moore, the Irish poet, visited the Happer house on his trip to Lake Drummond where he

This is the Happer House as it appeared in 1950 when it was purchased by Madison M. Riley. *Photo courtesy of Larry Floyd.*

received inspiration to write his famous ballad, "The Lake of the Dismal Swamp." There is no evidence to substantiate either claim. It has also been said that Dr. Hugo Owens, former vice mayor of the city of Chesapeake is descended from one or more of the slaves that worked on the Happer farm.

William Happer II is mentioned as having been a captain in the militia in 1760 and again on March 21, 1765. Prior to that, on March 20, 1760, he had qualified as a lieutenant in the colonial militia. In 1761, he was a vestryman at Saint Brides Parish and in 1764 he was elected church warden. In 1785, he served Norfolk County as a justice of the peace. Captain William Happer II died in 1788 and his will was probated on July 17, 1788.

Restoration of the Happer house seems to be an ongoing project. After years of neglect, Mat and Mrs. Riley beautifully and accurately restored it. The house is now owned by Victor and Lori Pickett. I visited with them on March 1, 2007, and found that a lot of work is still going on. I took many pictures and at least one of them will be included in this volume. As you will see, many changes have taken place since 1950 when the Rileys acquired the property.

Norfolk County Almshouse

Most of us are familiar with Charles Dickens's *A Christmas Carol* in which Scrooge was rather indifferent concerning the English poor. Actually the poor people were cared for by the established Church of England. During the colonial period the same policy was endorsed in the colonies. It was in the late eighteenth century when local governments began to appoint overseers rather than the churches to support poverty-stricken citizens with donated funds or to house them in facilities built for that purpose.

On December 18, 1854, George A. Wilson donated 175 acres to the Norfolk County overseers for construction of an almshouse. Wilson had originally acquired the land at an auction for the sum of $1,685. Upon completion, there were ten cottages with two rooms each. The superintendent lived in a large three-bedroom farmhouse at the center of the site. He, along with his children and residents who were able, tended the farm. The superintendent's wife cooked for all of them.

The poorhouse—also known as the County Farm or Almshouse—was a place where infirm residents lived. Although several families lived there, most had family members who were blind, mentally retarded, mentally ill, elderly or otherwise disabled. The county cared for these citizens from 1855 to 1929.

The poorhouse, which survived the Civil War, World War I and the Great Depression, is largely forgotten today. Very little is known about those who lived and died there. The woods behind present-day Chesapeake City Hall were the final resting place for many of the occupants of the poorhouse, at least until their bones were unearthed in 1997 to make room for the construction of the multimillion-dollar Chesapeake Jail addition. All the bones discovered were cremated and buried in nearby Chesapeake Memorial Gardens.

The Norfolk County supervisors voted in 1929 to send the eight remaining residents to the Norfolk Almshouse, paying the city of Norfolk one dollar per day, plus clothing for each

The Riley family renovated the original house and added a one-story wing on the west end of it. The Pickett family bought the house from the Rileys. This front view shows only a portion of the additions accomplished by Victor and Lori Pickett on March 1, 2007. *From the author's collection.*

Pleasant Grove

of them. Thus the County Farm or Almshouse closed in early 1930. For years afterwards, Cedar Road was known as Poorhouse Road. After the County Farm closed, families rented the small cottages in the 1940s and even into the 1950s.

Today the civic center at Great Bridge stands where the Almshouse, City Farm or Poorhouse once stood. The school administration building was constructed on land that once was used to grow cotton. Things change with time—in five or ten years it is quite possible that we will not recognize what are now familiar surroundings.

Chapter IX
Butts Road

Centreville—Fentress Historic District

Actually, two boroughs in the city of Chesapeake can lay claim to the Centreville-Fentress Historic District. While the larger part of the district is in Butts Road, a part of it crosses the boundary into the borough of Pleasant Grove.

The area where Centreville-Fentress is located was once the 1,350-acre farm of Joseph Pritchard. When he died in 1858 his will dated 1849 divided his estate between his wife and children. His eldest sons inherited most of his land and slaves. Pritchard left the kitchen furniture and one slave by the name of Pete to his wife. He willed a tract of 300 acres to his eldest daughters—Elizabeth, who was born in 1840, and Mary, born in 1842. This tract included the land to which Pritchard had given the name Centre Hill.

In 1858, William A. Jackson, whose farm was to the south and bordered the Pritchard land, purchased the three hundred acres inherited by the Pritchard sisters. The purchase price was twenty-five hundred dollars. Jackson, who was a young man of thirty years, had originally moved to the area from North Carolina. His farm was small, but with the addition of the three hundred acres, his landholdings were now about the average size for that time period. Throughout the years his acquisition of other properties had a major impact on the development of the community.

By 1871, Jackson had purchased numerous parcels of real estate in Norfolk County. When the year 1880 arrived, Jackson was considered to be a wealthy man, having seven servants and a cook. During the remaining years of the nineteenth century he continued to buy and sell property. His house, dating to 1870, was built on an elevated site, which may have been the land that was originally referred to as Centre Hill.

In July 1871, according to court records, William A. Jackson deeded a parcel of land for the amount of one dollar to the trustees of the Centre Hill Baptist Church. The land was to be used for the construction of a Baptist meetinghouse. The trustees listed were William Wood, Gideon S. Hearing, William H. Old, Sassell Jackson and Jerome B. Fentress. All were residents of the Centre Hill area.

A church built out of wood was constructed in 1872 along Great Road. The wood for the church was delivered by barge on the Albemarle and Chesapeake Canal to Old's Point. Along the way the barge sank, but the wood was salvaged and once dried, was used to construct the church. In 1925, the wooden church was moved and replaced with a two-story brick building. The church was a branch of the Pleasant Grove Baptist Church. Having begun with forty-one members in 1872, by 1882 the membership had grown to seventy-seven. The construction of the church marked the formation of a community center in the Centreville-Fentress area. Before 1872, the nearest church and commercial buildings were located at Mount Pleasant and Great Bridge, approximately four miles away.

The building of the Centreville Turnpike was a project accomplished by the local farm owners who had formed a corporation. The turnpike ran between Centreville and the Albemarle and Chesapeake Canal. The original road was a single track of oyster shells approximately ten feet wide. In addition to the turnpike, the group built the Centreville Turnpike Bridge. The bridge had a toll, which was collected by the owners or their agent. The group operated the bridge until its consolidation in 1913 by the Consolidated Turnpike Company.

William A. Jackson was involved in the creation of what is now the Centreville Turnpike. It went from Centreville-Fentress across the Albemarle and Chesapeake Canal toward Washington Point, which eventually became the town of Berkley. The

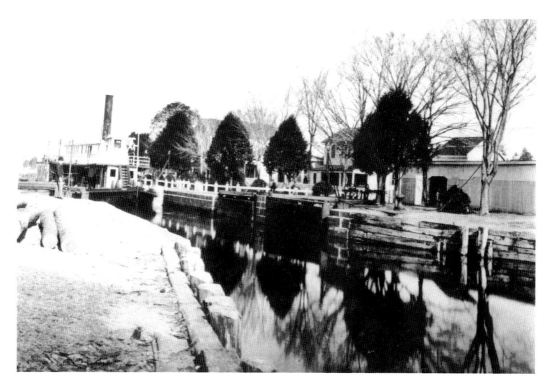

This picture, taken at Great Bridge in 1895, shows the steamboat *Comet* exiting the locks of the Albemarle and Chesapeake Canal. The canal opened in 1859 and was acquired by the federal government in 1913. *From the author's collection.*

creation of the Albemarle and Chesapeake Canal was a major development and economic factor for the Centreville-Fentress area. The canal linked the Southern Branch of the Elizabeth River at Great Bridge with the North Landing River, which then flowed to the Albemarle Sound. All of this facilitated travel between Hampton Roads, the Chesapeake Bay and the Currituck Sound. Old's Point is midway along the canal, just north of Centreville-Fentress.

The main purpose in developing the turnpike was to facilitate the movement of farm products from the Centreville-Fentress area to the docks at Old's Point on the Albemarle and Chesapeake Canal. The road preceded construction of the railroad line and was the only means of transporting goods to market, other than traveling four miles to Great Bridge or Mount Pleasant. The distance between Centreville-Fentress and the Albemarle and Chesapeake Canal was only one mile and the route was more economical and direct than the road to Great Bridge or Mount Pleasant. In addition, once the goods arrived at Great Bridge they had to be shipped once again from Great Bridge by steamer to the Northern markets.

Albemarle and Chesapeake Canal

Construction of the Albemarle and Chesapeake Canal began in 1855. As stated earlier, the Dismal Swamp Canal had provided the first water-related access between Virginia and North Carolina, but it was limited to small skiffs until 1814. In 1829, it was widened and could accommodate steamers. The Dismal Swamp Canal had been dug by hand and a road was built alongside to allow horses or mules to pull boats carrying logs out of the swamp.

The plan for the Albemarle and Chesapeake Canal dates back to 1772 when the need to connect the Elizabeth River with the Albemarle Sound was brought before the Virginia House of Burgesses. The purpose of the canal was to connect the headwaters of the Southern Branch of the Elizabeth River and the head of the North Landing River. It was realized at that time that the construction of the canal would facilitate and increase the trade between the Albemarle Sound and the ports of the Chesapeake Bay.

The Albemarle and Chesapeake Canal was dug by steam dredges, which were sometimes referred to as "iron titans." The job began at Great Bridge and ended at the head of the North Landing River. There was a single lock at Great Bridge. The first successful trip through the canal occurred on January 9, 1859, by the steamship *Calypso*, which was owned by the canal company. When the canal opened in 1859, business was immediately attracted away from the Dismal Swamp Canal. The development of Great Bridge as a major shipping point and town at that time was attributed to the opening of the canal.

In addition to development at Great Bridge, farms clustered along the waterway to take advantage of the ease of transporting goods. Docks were constructed on the canal for small boats, and small villages such as Mount Pleasant developed nearby and served as shipping hubs. Old Dock is one example of a dock constructed for the shipping of farmer's products to market.

Truck Farming

Truck farming has been mentioned several times before. But let's take a closer look at the terminology in order to better understand what truck farming was. The farmers in the Centreville-Fentress area were truck farmers, which means that they were farmers who transported or trucked their goods to market. Prior to the Civil War, truck farmers transported their goods by way of the Great Road to Great Bridge or Elizabeth City, North Carolina. From those locations, the goods could be transported by ship to other destinations on the Chesapeake Bay and Albemarle Sound. When the Albemarle and Chesapeake Canal opened, truck farmers were able to move their goods to market much faster. The Centreville-Fentress farmers moved their goods to Old's Point just north on the Albemarle and Chesapeake Canal for shipping. Therefore, the produce could be transferred when it was fresher and spent less time on the road en route to market.

The prosperity of Norfolk County farmers can be attributed to the fact that they were able to truck their goods by waterway. Since local crops matured one to two months sooner than those in the Northern areas such as Philadelphia, Baltimore, New York and Boston, it meant that there was an early market for their products. Another advantage for the Norfolk County farmers was the higher pricing of their goods in the Northern markets. The prices were higher simply because the farm products were available earlier, which enabled farmers to retain level pricing with shipping.

Transport of goods from the farm to the waterways was by way of horse or mule and cart along the shell roads where boats were available to move them to more distant ports. These boats were used during the summer months. After the harvest of produce, the same boats were used to harvest the sweet, plentiful oysters from the waters of the local rivers.

Also in the 1920s, tractors became available. Tractor manufacturers traveled the rural areas and demonstrated to the farmer the efficiency that could be gained by using the tractor instead of horses or mules for tilling the land. Just think how much the tractor, along with the truck, was able to expedite planting and harvesting of crops and the transport of the harvest to market.

The Railroad

In 1880, the Elizabeth City and Norfolk Railroad was formed with a route from Washington Point to Elizabeth City, North Carolina. The plan was that the railroad would connect Norfolk and Elizabeth City by rail and provide an alternative to shipping goods by the Albemarle and Chesapeake Canal. Both modes of transportation—the canal and the railroad—would coexist until the 1920s when the automobile and the trucking of goods were employed more often. Early trucks enabled the farmers to be more flexible in harvesting their crops and transporting them to market. This flexibility allowed farmers to harvest their crops at varying times. The produce could also be moved directly from the field to market and did not require an intermediate stop for transport, which cut out additional costs.

Construction of the Elizabeth City and Norfolk Railroad began in Berkley at Washington Point and was completed by December 1881 with a spur line to Edenton, North Carolina. Along the route stops were planned at Centreville and Hickory Ground near the Virginia and North Carolina border. Stations were constructed at these locations in Virginia to take advantage of the shipping trade for goods from the rich farmland, and to provide stations for the rural Norfolk County population.

In 1883, the railroad officially changed its name to Norfolk Southern and eventually consolidated with the Albemarle and Pantego Railroad and Steamboat Company. This company had been organized soon after the Civil War by John L. Roper of Norfolk. The railroad provided access to logging in the rich timberlands in southeast Virginia and northeast North Carolina. The company ran into financial problems and was placed in receivership in 1889. Receivers held the railroad until 1891 when it merged with Norfolk and Southern Railroad.

Norfolk and Southern Railroad prospered from the 1890s until World War I when they were forced to cut costs. Changes in modes of transport forced additional changes in Norfolk and Southern Railroad's shipping policies in the 1920s, and financial disaster occurred during the Great Depression in 1932.

During Norfolk and Southern Railroad's prosperous years, trains traveled daily between Washington Point and Elizabeth City and Edenton, North Carolina. Passenger service began in the 1880s, which allowed residents of Centreville-Fentress to travel to Norfolk and Elizabeth City. Passengers and transport service continued until the 1930s.

Commerce in Centreville-Fentress

Centreville-Fentress was an important crossroads in Norfolk County. It was centrally located and was on the mainland road from Great Bridge to Elizabeth City, North Carolina. The Centreville Turnpike traveled north across the Albemarle and Chesapeake Canal and connected with the Indian River Turnpike, which connected Norfolk and points east in Princess Anne County. Great Road was a more direct land route to Norfolk and passed through more heavily populated areas in the 1800s.

The first store in Centreville-Fentress was operated by Jetson Jett and was known as Jett's or possibly Jackson's Store. Jett's first appeared in the Centreville-Fentress area in a land sale from Jackson to Jett in 1871. By 1878, there were references to the store in the application of the Centreville Turnpike. According to deed records, the store was located at the intersection of Great Road and the railroad tracks near the intersecting roads. This was an excellent location for a store in the 1800s because people congregated at major shipping points.

In December 1888 application was made to the United States Post Office to open a branch at the Centreville railroad station. The proposed location was to be two hundred feet east of the railroad tracks. The application stated that the proposed office would serve five hundred people within the general vicinity. It was also proposed that Jerome Fentress serve as the postmaster and that the office be given the name Fentress. The

name Centreville was not available because it had been previously assigned to a village in northern Virginia.

In the late 1800s and early 1900s, the post office was a coveted business because members of the rural population had to visit the post office to retrieve their mail. As can be expected, the store where the post office was located became a popular meeting place and usually resulted in a nice increase in business for the owner.

Additional stores would eventually open in what became defined as a commercial area that developed at the intersection of Fentress Road (Great Road), Blue Ridge Road and Centreville Turnpike. In addition to these stores, in the late 1800s and early 1900s a hotel was located in the main commercial part of the town. Additional commerce developed in the early 1900s before the railroad terminal closed.

By 1900, William A. Jackson had grown quite old. Records show that he was now seventy-two years of age. He had also sold all of his land, abandoned the area he helped develop and had relocated to Park Place in the city of Norfolk. After he left, the village continued to thrive and it reached its peak in the early twentieth century.

By 1910, changes in the demographics of the population had occurred. There were now railroad personnel and some professionals in addition to those who were involved in agriculture. A.W. Burfoot had purchased the house that had been occupied by Joshua B. Fentress, who died without a will. In 1920 the community was known as Fentress Village and there was an auto repair shop with three employees. Also, there was a brick factory and additional commercial buildings east of Great Road and west of Centreville Turnpike on Blue Ridge Road. This expansion of the commercial core was indicative of a thriving community.

However, the arrival and popularity of the automobile made it possible for people to travel greater distances to shop. Also the national prosperity that followed World War I came to an end with the stock market crash in 1929. Between 1930 and 1940, the village of Centreville-Fentress as a commercial center declined very rapidly. Another major factor in the decline of the village was the troubled financial status of Norfolk and Southern Railroad between 1932 and 1940. In 1932, Norfolk and Southern filed for bankruptcy. This of course affected operations. With the uncertain future of the railroad and reduction in traffic, the reliability of the railroad lessened. Norfolk and Southern operated at a reduced schedule, and by 1941 it had been reorganized and service was cut to meet changes in demand.

Present-Day

Centreville-Fentress retains its post office, although it is limited in service. It is located in the last remaining store in the vicinity. Behind the store lie the original railroad line and the remaining platform for the train station. Though not serving as an agricultural village, the area still maintains its rural appearance. This is threatened with encroaching suburban development. Many small farmers have sold their lands, which have been planned as suburban communities or golf courses. The community, although surrounded by such development, still maintains its rural and agricultural character.

All of Norfolk County faced major changes in the twentieth century with the formation of the city of Chesapeake and numerous annexations by the city of Norfolk. Norfolk, which is landlocked, sought to increase its borders by annexing portions of Norfolk County. Between 1887 and 1955, the city of Norfolk annexed twenty-three areas from Norfolk County. In 1963, the city of Chesapeake was formed from the remaining lands of Norfolk County and the city of South Norfolk.

Cuffeytown

Free Africans have lived in a section of what is now Chesapeake since colonial times. Cuffeytown, in southern Chesapeake, is the oldest continuous community of freeborn Africans in the country. About two hundred descendants of those original settlers still live in the community that was a part of Norfolk County.

East of Hickory, the community is now surrounded by modern subdivisions. Cuffeytown stretches along Long Ridge, Head of River, Land of Promise and Beaver Dam Roads. So far, no explanation has been found as to how the early settlers of Cuffeytown managed to obtain their freedom. More than forty men from that community served in the Union army during the Civil War, and Cuffeytown Road received its name in order to commemorate their service. Thirteen of the soldiers, referred to as the Cuffeytown Patriots, are buried in the historical cemetery at the intersection of Cuffeytown and Cuffey Roads.

After the Civil War, in October 1865, a group of citizens from Cuffeytown and the American Missionary Association organized the Cuffeytown School for Colored Children. Until then there were no schools in Norfolk County that were dedicated to educating the black children. It was not until 1871 that public education returned to Norfolk County.

The Gabriel Chapel African Methodist Episcopal Zion Church, the oldest AMEZ church in Chesapeake, was founded in 1866. The church is located at 2216 Long Ridge Road. A historical marker has been placed at the church to mark the Cuffeytown site.

Chapter X

Deep Creek and the Dismal Swamp

The borough of Deep Creek received its name from its waterway—the mouth of which is part of the Southern Branch of the Elizabeth River—which was discovered by early colonists from Jamestown. They found that it could easily accommodate large boats to the Dismal Swamp and the thousands of trees that could provide lumber for building ships. The harvesting of lumber caused people to settle on the fringes of the swamp; most of them living at the village of Deep Creek. The settlement was the halfway point between Jamestown and North Carolina. During colonial times, it has been said that Deep Creek had at least four hotels and a tavern to accommodate travelers on their way to North Carolina.

When Deep Creek is mentioned, many people may remember the antebellum homes and churches in the area, but the section has, in addition to its new homes, a fascinating colonial era history as well.

During the seventeenth and eighteenth centuries, religious persecution existed in the colony of Virginia. The Church of England was the established church, and dissenters were not welcome. Prior to the Revolution, there were Baptists, Presbyterians and Methodists living in Virginia, but very few had located to the southeastern section of the colony.

It was in 1778 that Virginia enacted the Statute for Religious Freedom. After that, members of all religious sects were free to practice their own beliefs, and at the close of the Revolution, the number of Baptists, Presbyterians and Methodists increased greatly. Many of them were baptized in the waters of the Deep Creek in Norfolk County.

Baptists settled in Deep Creek as early as 1785. That year, twelve people from that village were received into membership of the new Shoulder's Hill Baptist Church in Nansemond County. One of them, a man named Jeremiah Ritter, later became a minister and served the Shoulder's Hill Church, which later became the Churchland Baptist Church.

Nothing, however, is known after that time of a Baptist Church in Deep Creek until 1830. At that time, the Portsmouth Baptist Association listed a church from that area, with Reverend Jeremiah Hendren as a delegate. Nothing further was heard from the church, and it was dropped from the association in 1840. A report made by the state

A History of Chesapeake, Virginia

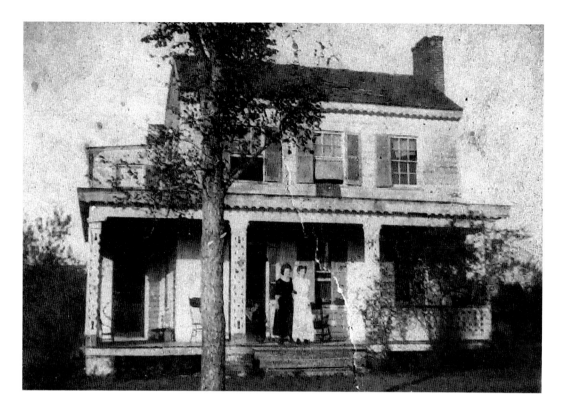

This house was built before the Civil War and served as a hospital during the war. It was located on what is now Cedar Road between Twin Cedar Trail and Terwillinger Road. The property was sold in 1960 and the house has since been demolished. *From the collection of J.E. Rich.*

missionary in 1852 mentioned thirty-two members of a Baptist Sunday school in Deep Creek. The superintendent was listed as Absolom Cherry. The missionary indicated that these persons were eager to form a church, but no church was organized until after the Civil War.

On August 29, 1869, three ministers—Reverend N.B. Cobb, Reverend Harvey Hatcher and Reverend J.G. Hobday—met in the home of Mrs. Josephine Cherry, and the Deep Creek Baptist Church was formed with seventeen charter members. In April 1870 Reverend A. Paul Repiton began serving as the first minister. His salary was $150 per annum.

Construction of a church building began in 1871, and in 1875, on the fourth Sunday in April, the edifice was dedicated. Painted a reddish brown in color, it was a rough frame building erected on land leased from the Lake Drummond Canal and Water Company for ninety-nine years at the rate of one dollar per year. A lease recorded in the clerk's office of the circuit court of the city of Chesapeake lists George W. Brown, E.B. Hurdle and George W. Culpepper Sr. as trustees of the Deep Creek Baptist Church.

Around 1893, the church was remodeled and a new steeple and bell were added. At that time baptisms were still being conducted in the Deep Creek; however, in 1925, a baptistery would be built in the new church. Mrs. Mary A. Deal, widow of a charter

Deep Creek and the Dismal Swamp

This is the village of Deep Creek as it appeared in a photo taken by H.C. Mann in 1910. Looking south along George Washington Highway we can see the Methodist and Baptist churches on the *left* and the public school on the *right*. *From the author's collection.*

member and former deacon of the church, broke ground for a new brick church to be erected on the site of the original building in February 1925. The house of worship, which was dedicated by the state missionary, was constructed at a cost of $32,300. Reverend W.L. Larsen conducted the first service in November 1925.

The Deep Creek Baptist Church purchased the land on which the building stood from the U.S. government in the year 1940. The deed was dated November 6, 1940. During the mid-1940s, a brick parsonage was completed, and in 1957, an educational building was erected at a cost of $162,000.

The church on Mill Creek Parkway in Deep Creek has served the residents of old Norfolk County and those of the city of Chesapeake for almost 140 years.

In the early 1900s, Deep Creek was mostly a farming community. The small number of farming families raised corn, sweet potatoes, Irish potatoes, snap beans and strawberries. Fresh produce began to replace lumber as the main cargo on the steamboats. The town had only three or four stores, so most of the shopping was done in Portsmouth.

In 1907, John L. Roper operated a lumber company in the nearby town of Gilmerton (named for Governor Thomas Walker Gilmer) along the Elizabeth River. The plant provided employment for a few Deep Creek citizens. The residents of Gilmerton, like those

The information available with this photo states that it was taken in the back of the Deep Creek Church. Judging by the shape of the building and windows it was probably the early Baptist church. *From the author's collection.*

of Deep Creek, did most of their shopping in Portsmouth; however, they had one advantage over the folks from Deep Creek and that was the streetcar. In those days, streetcar service was available to the residents of Gilmerton.

In 1910, a beautiful new school was built to serve both the Deep Creek grammar and high school students. Transportation to and from the school was furnished by horse-driven school buses and wagons equipped with roll canvas curtains that provided shelter during inclement weather. By 1955, an additional building had been constructed next to the one built in 1910. Both still stand along George Washington Highway across from Chesapeake Fire Station Number Eight. Throughout the years, additional schools have been added in the Deep Creek Borough.

A short distance from the old school buildings and the fire station is White's Old Mill Garden Center on Old Mill Road where all kinds of plants, trees, shrubbery, flowers and supplies can be found. In December their large greenhouse is filled with bright red poinsettias and in March and April the poinsettias are replaced by Easter lilies.

The local lumber camps, gristmills, wharves and railroad depot have all disappeared. The *Emma Kay* no longer plows the waters of the Elizabeth River, picking up passengers on its way to Portsmouth and Norfolk. However, like Western Branch and Great Bridge, the population of Deep Creek has more than doubled since the merger in 1963.

As mentioned, Deep Creek, like many other areas of Norfolk County, depended on farming for its existence. With the Great Depression of 1929 came bank foreclosures, which led to the loss of many individual farms. Fewer farms meant less produce for the boats that

Deep Creek and the Dismal Swamp

This picture was taken at the Virginian Railroad crossing on the George Washington Highway, circa 1925. *Photo courtesy of Stuart Smith.*

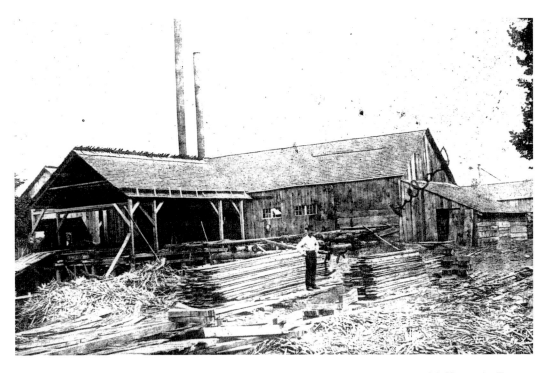

This photograph was taken of a sawmill operated by M. Ervin Hillard, father of Major M. Hillard Sr. The exact location is unknown; however, the Hillards had a small mill near the intersection of Terwillinger and Cedar Roads. The mill was near their residence on what is now Cedar Road. *From the collection of J.E. Rich.*

ran between Norfolk County and the Roanoke Docks in Norfolk. Through all the lean years, some logs were still harvested from the Dismal Swamp.

The Dismal Swamp

According to geological information, many years ago an ancient sea extended to what is now the western border of the Dismal Swamp producing sandy beaches and thick jungles in the area where the present-day swamp is located.

It is believed that the Great Dismal Swamp was at one time a part of the area that was controlled by Chief Powhatan. The Native Americans felt that the swamp belonged to the Great Spirit, and because of that, none of the tribes lived inside it. The tribes from the south camped on Smith's Ridge in North Carolina and those to the north and west congregated in the area that is now Deep Creek. From those two locations, the Native Americans hunted, trapped and fished in the Great Dismal. They took what they needed and used all that they took.

Seventeenth-century maps of Lower Norfolk County show areas referred to as "black water." The belief is that those regions were part of the swamp. At that time, the life expectancy in the Chesapeake Bay area was lower than in the Northern colonies, and the swamp has been blamed for the unhealthy conditions that existed. It has never been determined exactly what diseases took the greatest toll; however, it is certain that dysentery was responsible for many deaths.

Lake Drummond, in the middle of the Dismal Swamp, was named for William Drummond, the first governor of North Carolina (1663–1667), who discovered the lake while on a hunting trip. The governor was the only member of the hunting party to return—his three other companions perished. Governor Drummond was not privileged to participate in later developments of the swamp, because about ten years later he was hanged at what was then known as Middle Plantation, Virginia. This later became Williamsburg. In 1676, he was tried and found guilty as a traitor, for he had taken part in Bacon's Rebellion against Governor Sir William Berkeley of Virginia.

The surface of Lake Drummond is twenty-two feet above sea level and it is approximately three miles in diameter. The original depth was about fifteen feet before man began to remove timber and drain the swamp into feeder ditches. This lowered the level and it now averages six feet.

When Colonel William Byrd II was in the area in 1728 to survey and run a boundary between the colonies of Virginia and North Carolina, he made many observations of the swamp. He discovered a large area of green cane, which grew fifteen feet in height. He gave this place the name Green Sea. Byrd called the great freshwater morass "a frightful place." He found nothing charming about it. He wrote that not even birds would fly over it "for fear of the noisome exhalations that rise from the vast body of dirt and nastiness." Byrd and his party were almost devoured by yellow flies, chiggers and ticks. The party got lost and ran out of food. These unpleasant experiences—along with the difficulties of penetrating the dense jungle—most certainly colored his impressions and partially accounted for the bad report he gave the swamp. Byrd is credited with

giving it the name Dismal Swamp. Although Byrd found the swamp to be a dreadful place, while in the area in 1728 he managed to propose construction of the Dismal Swamp Canal.

Unlike Colonel Byrd, many others found opportunity and inspiration from the Dismal Swamp. In 1803, the popular Irish poet Thomas Moore (1779–1852) visited Lake Drummond and the Dismal Swamp. As the story goes, while sipping suds in a Norfolk tavern, he heard the Native American legend of the lady in the lake. Moore found the lake to be the perfect setting for his piece "A Ballad: The Lake of the Dismal Swamp," which tells of a deranged lover searching for his dead sweetheart whom he imagines lost in the waters of the Dismal Swamp. The famous novelist Harriet Beecher Stowe (1811–1896) used Virginia's Nat Turner insurrection for her novel *Dred: A Tale of the Dismal Swamp*, written in 1856. On the eve of the Civil War, New England poet Henry Wadsworth Longfellow (1807–1882) wrote of a runaway slave who seeks refuge in the swamp in his poem "The Slave in the Dismal Swamp." David Hunter Strother sketched and wrote about the swamp for *Harper's* in 1857. In the latter part of 1894, the poet Robert Frost, being disappointed with his girlfriend, Elinor White, took a merchant marine ship from New York to Norfolk, Virginia, where he planned to eventually lose himself in the Dismal Swamp and never return. From Norfolk he began to walk towards the village of Deep Creek. He felt that there he would find the best road into the swamp. However, as he got deeper into the swamp he changed his mind. Upon meeting a lock keeper he asked if he could arrange a ride for him to the nearest town, which was Elizabeth City, North Carolina. Three weeks later, after having received food and shelter from strangers along the way, Frost finally arrived home. Throughout the years, the Dismal Swamp and Lake Drummond have served many writers in a variety of ways.

The water found in the Dismal Swamp is very acidic and tan in color from the juniper and cypress trees and stumps. It has been said that many early ships carried casks of this swamp water with them on long ocean voyages and used it for drinking water.

While Byrd observed no wildlife in the Dismal Swamp, naturalist Dr. Paul Bartsch, in June 1899, found the swamp filled with musical sounds and listed fifty-two different kinds of birds, which he observed on two summer trips. In more recent years, the white-tailed deer population is probably the most abundant of the swamp's larger animals. Then there are the black bears that average between 150 and 300 pounds, with the largest ones weighing nearly 400 pounds. Almost two hundred species of birds have been identified, along with many different types of reptiles and amphibians. The plants within the swamp are as diverse as the animal population. The red maple has replaced the white cedar and cypress that once thrived in the swamp.

About thirty-five years after Colonel Byrd's trip, George Washington made his first visit to the swamp in 1763 when he was thirty-one years old. Washington, with the eye of a hopeful investor, found it a glorious paradise abounding in wild fowl and game. He, as did Byrd, sensed the practical value of connecting Virginia with North Carolina by means of a ship canal and a stage road. Washington made seven trips into the swamp. He has been credited with surveying much of it, but Greshom Nimmo did the actual survey for Washington. Washington is also credited with discovering the headwaters of the Nansemond River.

This is a part of the Dismal Swamp Canal as it appeared on May 7, 1940. *Courtesy of Sargeant Memorial Room, Norfolk Public Library, Norfolk, Virginia.*

George Washington, along with Patrick Henry, Thomas and William Nelson, Thomas Walker, Robert Tucker and others, organized a lumber company called Adventurers for Draining the Dismal Swamp. The royal council of the Virginia Colony granted them forty thousand acres in the swamp. Three years later, Washington and Fielding Lewis acquired an additional eleven hundred acres in the Dismal Swamp.

After Washington's death in 1799, his executors purchased his holdings, which remained in possession of Judge Bushrod Washington and his heirs for about a hundred years. William N. Camp of Camp Manufacturing later purchased the Washington property and it became a part of Union Bag–Camp Manufacturing.

Camp at one time owned about half—approximately fifty thousand acres—of the Dismal Swamp in Virginia and used it for the production of timber. A large amount in North Carolina has been reclaimed for agriculture.

William Byrd had first proposed the Dismal Swamp Canal early in the eighteenth century, but it was not authorized by the Virginia General Assembly until 1787 and was ratified by North Carolina in 1790. The Dismal Swamp Canal Company, using mostly slave labor, began construction in 1793 at both ends of the proposed cut. The intent was to connect the Southern Branch of the Elizabeth River near Norfolk with the Pasquotank River in Camden County, North Carolina. Because the canal was dug by hand, progress was slow and expenses were high. The cut was completed in 1805 and a

toll was placed on the east bank. The canal was fifteen feet wide and had two locks. A feeder ditch to Lake Drummond was cut and four locks were added in 1812. Between 1827 and 1829, the waterway was widened and made deeper, and the wooden locks were replaced with locks of stone.

Throughout the years many logs were harvested from the Dismal Swamp, and in 1830 a railroad was laid through part of it. This made it easier to haul the timber, shingles and other wood products out of the swamp to places where they could be shipped to local and foreign markets.

Completion of the Albemarle and Chesapeake Canal in 1858 dealt a serious blow to the Dismal Swamp Canal. During and after the Civil War, the canal became badly deteriorated, and the owners, being nearly bankrupt, sold its interest. The new owner made many improvements between 1896 and 1899 and removed all but two locks. In 1912 –1913, the U.S. government purchased the Albemarle and Chesapeake Canal and made it toll free. The Lake Drummond Canal and Water Company could not compete, and the Dismal Swamp Canal again began to deteriorate. In 1929, the U.S. government bought the Dismal Swamp Canal and began to make improvements. In 1933, the channel was widened and made deeper. In 1933–1934, new drawbridges were built at Deep Creek and South Mills. In 1935, a new control spillway was built at Lake Drummond. In 1940–1941, new locks were built at Deep Creek and South Mills. In 1963–1964, new canal control spillways were built at both ends of the canal. Maintenance dredging is done periodically.

Now on the National Historic Register, the Dismal Swamp Canal is the oldest operating artificial waterway in the country. Both the Albemarle and Chesapeake and the Dismal Swamp Canals are operated by the Army Corps of Engineers and form a part of the Atlantic Intracoastal Waterway.

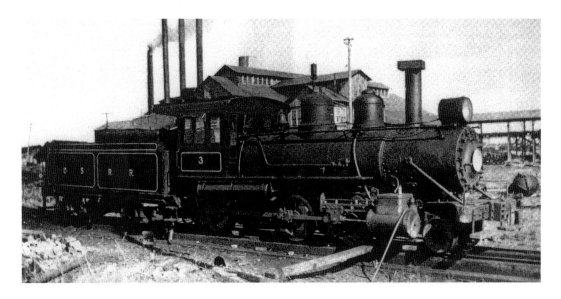

The Dismal Swamp Railroad ran on a narrow-gauge track—three feet six inches. Number three locomotive is shown here in 1937 as an oil burner at Camden Mills, Virginia, on the south bank of the Albemarle and Chesapeake Canal. *Photo courtesy of Stuart Smith.*

In 1964, the Chesapeake Chamber of Commerce launched a study to determine the tourist possibilities of the Great Dismal Swamp and to recommend development of facilities there that would help attract visitors. At the same time, the state of Virginia was studying possible sites in the swamp for a state forest. A ten-thousand-dollar grant was made available by the General Assembly for the study. Although there was great interest shown by several organizations, both plans died in the early stages. The main ingredient that would have ensured success was missing, and that ingredient was funding.

The swamp is now known as the Great Dismal Swamp National Wildlife Refuge. It is a place where people can enjoy bird-watching, hiking, boating, hunting and even horseback riding. In my youth it was a place to go in December to collect holly and mistletoe. During the Civil War, the Great Dismal Swamp was a place for runaway slaves from the local area to hide. It was part of the Underground Railroad to Freedom.

According to an editorial in the June 4, 2007 edition of *The Virginian-Pilot* newspaper, the campground at Lake Drummond in the middle of the Dismal Swamp is in danger of being closed. The remote location and inaccessibility of the site and the fact that nighttime staffing is not available are the reasons given for possibly closing the campgrounds.

On Saturday, April 14, 2007, the first Dismal Swamp Stomp Half Marathon took participants on a 13.1-mile track, now called the Dismal Swamp Canal Trail. The trail was formerly old U.S. Route 17, which was closed to traffic two years ago. Runners in Chesapeake jogged on a track alongside the historic Dismal Swamp Canal. The 8.5-mile abandoned roadbed is supervised by the Chesapeake Parks and Recreation Department. It was dedicated a year ago. Phase two of the project, which is still in the planning stage, will include a ranger station, boat ramps, historic and scientific trail designation and signage.

The trail offers a lot of recreational opportunities for bikers, walker, runners and four-legged friends. It has received tremendous use from families with baby carriages as well as young people on roller skates. In other words, it has been well received by the local citizens.

Dismal Swamp Railroad

The Dismal Swamp Railroad was a forty-two-inch gauge line constructed during the late 1890s and early 1900s. It ran about thirty-five miles through the swamp in southeastern Virginia and northeastern North Carolina and served mostly as a logging railroad for the Richmond Cedar Works. The eastern terminal of the Dismal Swamp Railroad was located at the Camden Mills, Virginia, sawmill on the south bank of the Albemarle and Chesapeake Canal about one mile west of the Great Bridge locks and due south of Norfolk. At one time the railroad shops of the company were located at the logging camp known as Benefit, Virginia, seven miles southwest of Camden Mills.

For a number of years the Dismal Swamp Railroad operated as a subsidiary of the Richmond Cedar Works, whose major sawmill was located at Camden Mills and the main manufacturing plant at Richmond, Virginia. Lumber prepared at the mill was shipped by barge, which was towed up the James River to Richmond.

Deep Creek and the Dismal Swamp

Over the years, power for the railroad was accomplished by steam locomotives. In later years all the locomotives were fueled by burning oil in order to reduce the danger of setting fire to the timberlands in the swamp. Use of the narrow-gauge Dismal Swamp Railroad was discontinued in 1941.

Richmond Cedar Works

Richmond Cedar Works was organized in 1870, and when it was incorporated twenty years later, its holdings included three hundred thousand acres of rich timberland, a large part of which was in the Dismal Swamp. The main operation and offices were in Richmond, Virginia. It was there that the company produced many varieties of wooden products, including furniture. A specialty item that was manufactured from cedar wood was the ice cream freezer tub. In earlier years most homes owned an ice cream freezer, which received a considerable amount of use in the summer months.

The Camden Mills sawmill was established around 1900. In its busiest times a narrow-gauge railroad brought fresh-cut cypress, cedar and juniper from the Dismal Swamp to the sawmill. Eventually trucks were used to transport the logs and the railroad tracks were removed. The large planning mill at Camden burned in the late 1940s, and by 1960 the company ceased operation.

Richmond Cedar Works employed a large number of local people. It also operated a commissary on the premises. The employees were allowed to make purchases and charge them. When payday came it was also time to pay the company store. As an old song once went, "you owed your life to the company store," and that was a fact of life.

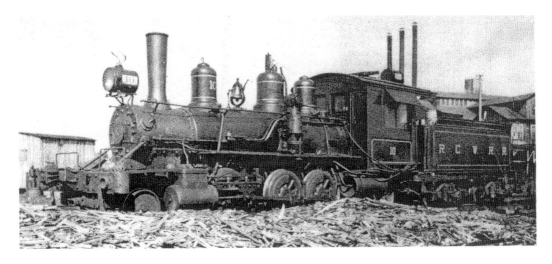

The Richmond Cedar Works Railroad was used mostly to haul juniper, cypress and cedar logs from the Dismal Swamp to the Richmond Cedar Works mills at Camden, Virginia, which was about a mile from Great Bridge. *Photo courtesy of Stuart Smith.*

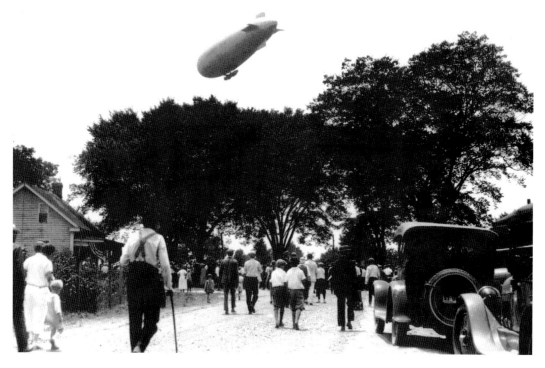

These people gathered at Wallaceton in Norfolk County on July 17, 1925, to celebrate the opening of that part of the George Washington Highway. *Courtesy of Sargeant Memorial Room, Norfolk Public Library, Norfolk, Virginia.*

The George Washington Highway

In 1890, construction began on what was then known as the Canal Road. This early road later became known as the George Washington Highway or U.S. Route 17. Today, the George Washington Highway runs from the Dismal Swamp Canal Trail to Victory Boulevard.

Wallaceton

Wallaceton was in the southern part of Norfolk County near the Dismal Swamp Canal. It has been said that "Wallaceton was not so much a town as a state of mind." In 1920 there were two dwellings, a combination country store and post office and one sawmill in the remote suburbs on the far side of the canal.

It was around the year 1841 that the first portion of Glencoe was built on the Dismal Swamp Canal near the Northwest Canal locks. George Wallace moved there with his wife Elizabeth Curtis Wallace and their two children. After the move to Glencoe in Wallaceton, George and Elizabeth would have four more children.

Glencoe, the beautiful three-story frame house, which became a landmark in the area, was destroyed by fire on Thanksgiving morning in 1977.

Deep Creek and the Dismal Swamp

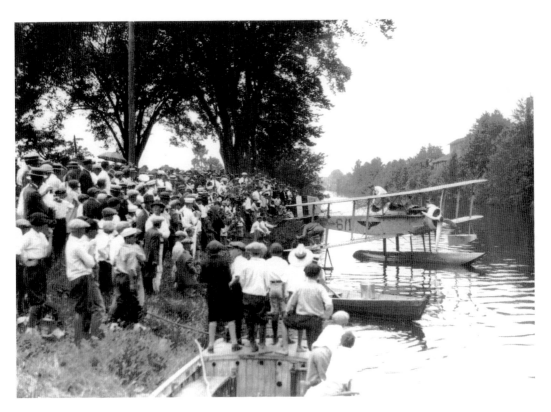

This seaplane, which was scheduled to be a part of the celebration of the opening of the George Washington Highway at Wallaceton on July 17, 1925, seems to be having trouble. However, it gave the people a chance to see something that they probably had never seen before and that was a flying machine up close. *Courtesy of Sargeant Memorial Room, Norfolk Public Library, Norfolk, Virginia.*

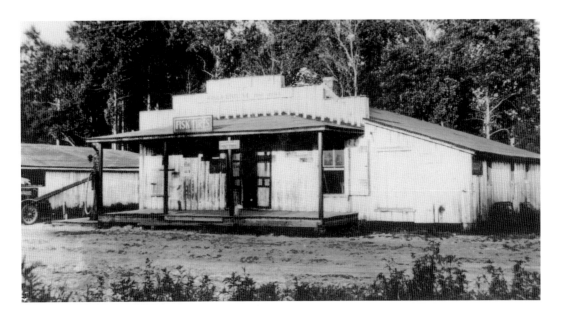

This very old building housed the Wallaceton, Virginia, post office and general store. Note the hand crank gas pump near the *left* side of the image. *From the author's collection.*

Chapter XI
Western Branch

The Chesapeake community of Western Branch is located between the Nansemond River and the Western Branch of the Elizabeth River. Prior to 1600, it was a wilderness with an abundance of large trees and a variety of wildlife—fish, oysters, crabs and clams filled the surrounding waters.

The Chesapeake and Nansemond Indians were the closest tribes to Western Branch. Dumpling Island on the Nansemond River, about nine miles west of Western Branch, was home to a large village of Nansemond Indians consisting of about 850 people. Due to the tidal waters around the island, there was an abundance of seafood. The rich soil provided the Native Americans with plentiful crops such as squash, beans and corn. These foods, along with those acquired by hunting and fishing, supplied the inhabitants of Dumpling Island with a more than sufficient diet. Dumpling Island was also an important trading post where the English came to trade with the Native Americans. The Chesapeake Indians occupied the land between the Elizabeth River and the ocean, and were enemies of the Powhatan and Nansemond tribes. In fact, the Chesapeake Indians' culture and people were all but wiped out by wars with the other two tribes.

Between the years 1632 and 1634 the General Assembly divided Virginia into eight shires or counties. At that time, Western Branch was a part of the Elizabeth City shire. The Elizabeth City shire became New Norfolk County in 1636 and was subsequently divided into Upper and Lower Norfolk Counties. It was in April 1691 that Lower Norfolk County was split into two separate entities—Norfolk and Princess Anne Counties. The community of Western Branch was a part of Norfolk County and remained so until the merger with the city of South Norfolk on January 1, 1963.

The farmers of Western Branch received their land in the early 1600s as a gift, a purchase or a head right. When the king of England granted land to an individual as repayment for a favor or debt that was considered a gift. A head right was when the Crown of England gave fifty acres to a colonist for each new member sponsored into the colony. This was the way that most farmers received their land. Of course, land could also be purchased. There were many settlers in Western Branch, and the largest landowners

were John Sipsey, who owned fifteen hundred acres; James Knoch, twelve hundred acres; and Francis Hough, eight hundred acres.

Most early surveyors in the colony had also been farmers in England. So when they surveyed a piece of property they would use the edge of a body of water as a starting point and run the boundaries at right angles. Therefore, creeks bound most of the farms in Western Branch.

In the late 1600s some land began to change hands. Norfolk County court records dated March 15, 1694, list the sale of about four or five acres at the head of the Western Branch by John Tucker and his wife Mary to Andrew Taylor for and in consideration of eight pairs of French fall shoes.

The years before the Revolutionary War with England were turbulent for the people of Western Branch. Outrageous taxes and problems with England were felt on the farms and plantations. Patrick Henry's now famous words, "give me Liberty or give me death," disturbed Royal Governor Lord Dunmore to the point that he confiscated all the guns and gunpowder belonging to the colonists and hid them. Many men in Western Branch, who worried about the safety of their families, enlisted in the Continental army. When the colonists found that there was likely to be a struggle with England, they immediately began enlisting minutemen. The citizens of Western Branch were ready for war, and the year 1776 brought the American Revolution. Norfolk County was asked to furnish fifty-six men. The farmers of Western Branch helped the war effort by supplying their quota of produce, meats, rum and whiskey. After the war, land belonging to colonists that had supported England was seized and sold at auction. These people were also forced to return to England.

The early settlers of Western Branch found fertile soil, and as a result, the economy during this period was mainly agricultural. Eventually tobacco became the main crop and was even accepted as legal currency. By the year 1705 when you sold a "hogshead" (barrel) of tobacco, you received a "tobacco note," which was used in that county as legal tender for all debts and purchases. The wages of Norfolk County officials, clergymen and soldiers were all paid with tobacco. The economy of Western Branch was also dependent upon the prosperous truck farms in the area. It was then that the value of land began to rise rapidly. A farm that sold for $4,000 in 1842, brought $18,500 in 1855. Before the introduction of refrigerated rail cars, the area was situated in a key position to supply the vegetable needs of many of the great Northern cities. Following the Civil War, stops along the Norfolk & Southern Railroad at Centreville, Hickory, Indian Creek and other places encouraged the growth of truck farms. The railroad carried tons of locally raised farm produce to town before a combination of good roads and motor trucks began to compete for the business.

The importance of the church to members of the colony cannot be overstated. It was on November 18, 1618, that the Virginia Company's London Council ordered that the colony be divided into four large corporations. For purposes of local administration, each was to be a parish of the Church of England. Each corporation was to have a chief executive and military officer and later either justices or a court of law. As each corporation was an ecclesiastical parish, each was required to have a minister, churchwardens and vestry. The minister's salary was to be paid by the landowners.

Western Branch

The Anglican Church was the Church of England, and under instructions dated July 24, 1621, Governor George Yeardley of the colony was required to "keep up religion of the Church of England as near as may be." In March 1761 the General Assembly divided the Elizabeth River Parish into three parishes. They were the Elizabeth River, Saint Brides and Portsmouth Parishes. Western Branch became a part of the Portsmouth Parish.

Religion was very important to the citizens of Western Branch. The church was not only the center of religious devotion but it was also the center of social life. The Glebe Church, which was built in 1738 and received repairs in 1854, was located to the west of the Western Branch area. Near the Hodges Ferry Bridge there was a sign that indicated that an early church once stood in the vicinity of the bridge. It is not known for sure, but it is possible that it was what is known as the missing church of Western Branch.

In 1850 the Indian Methodist Church was built in Bowers Hill. Union soldiers burned the first sanctuary in 1862. After the Civil War, the next church building along with its school was built in 1871. Fifty years later in 1921, this structure was destroyed by fire. Not long after that a third building was constructed. This is the meeting place of the Nansemond tribe, which is the only state-recognized tribe in the city of Chesapeake.

The Churchland Baptist Church, established in 1785, was originally known as the Shoulder's Hill Baptist Church and was located in old Nansemond about midway between Portsmouth and Suffolk. In 1829, a second building was erected on Sycamore Hill, and it was then that the name was changed to Churchland Baptist Church. Robert Williams founded the Jolliff United Methodist Church, which was originally known as the Jolliff Meetinghouse, in 1798; however, the present church was constructed around 1850. The Jolliff Methodist Church was one of the original churches in Western Branch and was located on "The Road," which in colonial times was the main route from Suffolk to Portsmouth and is known today as Jolliff Road and Portsmouth Boulevard.

Around the turn of the century (from the 1800s to 1900s), attracted by the lure of rich farmland at reasonable prices, a number of families of Polish descent settled in the Bowers Hill–Sunray section of Western Branch. As the community grew and prospered, Saint Mary's Catholic Church—the first congregation of this denomination in the area—was established in 1915. Religious affiliations were as varied back then as they are today and included Baptists, Methodists, Episcopalians, Catholics, Jews and possibly other denominations.

Shipbuilding was one of the major industries in this area. Since there were only a few dirt paths that were used as roads, boats became the colonists' main means of transportation and were also used for shipment of their products to markets. Woods such as cedar, oak, walnut, pine and others used for building ships were plentiful. Materials needed for making rope were also plentiful. England and Holland, who had been acquiring shipbuilding materials from both Poland and Prussia, were now able to purchase them from the colony of Virginia at half their previous costs.

The establishment of two laws encouraged expansion of the shipbuilding industry in the area. One law stated that larger boats would be allowed to carry more tobacco and the other offered the colonists a discount in taxes on imports and exports if they used their

own boats. While shipbuilding was accomplished along the entire waterfront, the largest shipyards were located at Lovett's Point. In later years this would be the location of the Virginia Chemical Company.

The Norfolk Naval Shipyard, formerly known as the Gosport Naval Shipyard, has been in existence since November 1, 1767. It started as a private business and in 1801 was acquired by the federal government from the Commonwealth of Virginia. It is especially remembered for the first dry-dock in America and as the building site of the Confederate ironclad *Virginia*, formerly the *Merrimac*.

The oldest house in Western Branch, the Bruce-Speers House, can be found in Green Meadow Point East. It is located on Drum Creek and was built by Abraham Bruce in 1690 on a Native American burial site. The property, which was known as Churchpoint Plantation, originally consisted of twenty-two hundred acres (today there are only six acres remaining), and boasted a mill, wharf and brick kiln. The wharf had the only deep-water landing on Drum Creek; consequently, the Churchpoint Plantation was able to ship goods to England, Norfolk, Baltimore and New York. The property was acquired by a land grant from King Charles I to his cousins Charles William Bruce and Richard William Bruce in 1634. Richard settled on the Western Branch property while Charles Edward settled on Brandon Estate near Richmond on the James River. The cousins were sent to Virginia to keep an eye on Sir William Berkeley, who was the royal governor at that time. (Berkeley was governor from October 1660–April 27, 1677.)

In 1720, a larger plantation house was constructed, and the original house became home to the overseer. In 1760, the west wing, which included a kitchen, was added to the house that was erected in 1720. The existing back of the house was attached in 1930 and the east wing, which includes a library and a new master bedroom, was added in 1981. As with many early houses, electricity was not available until the twentieth century.

In 1776, the Bruce family supported the American Revolution. In more recent years while installing insulation and new plaster in some of the walls, an original Revolutionary recruiting poster along with eight dollars was found. The poster stated in large letters, "Take Notice to all brave, healthy, able bodied and well disposed young men to serve under General Washington for the defense of the liberties and independence." Among other articles found in the walls throughout the years was a doll baby, which was reported to have a beautiful face, portraits, an early photograph of Edward Miars Bruce who died in 1935 and a letter from John W.W. Snead written from Camp Jackson, Virginia, and dated May 3, 1862. The contents of the letter mentioned that fifteen dollars were enclosed for five weeks hire of a slave boy by the name of Levi, and Mr. Snead stated that he would like to continue to retain his services until further notice.

By 1840, the twenty-two hundred acres of the Churchpoint Plantation had been divided among the seven children of William A. Bruce. The names given to the seven farms were Bruce, Deans, Duke, Jones, King, Mackie and Peake.

In the early years, a means of communication between the farms and plantations was needed. Attaching a rope to a large bell and mounting it on a tall pole satisfied this need. The bell served to warn nearby farm and plantation owners of impending dangers. The code used during the Civil War was one ring for farm business. Two rings indicated that

Union soldiers were attacking and three rings meant that there was a fire. Eight bells informed the neighbors of a death.

Unusual Stories about the Bruce-Speers House

Some people do not believe in ghosts. But the folks that lived in the Bruce-Speers House throughout its history of more than three hundred years have recorded stories that would indicate that possibly four or five of the pesky creatures took up residence on the property.

During the Civil War, Mrs. Louisa Bruce King occupied the house. One day, when a door to the house was open, an officer from the Union army rode his horse up the steps and into the living room. Mrs. King, not being partial to Yankees, grabbed a shotgun and blasted him. Not knowing what to do with the body, they eventually decided to bury him under the house where his remains are to this day. The soldier's sword and pistol are still in the possession of family members. As for the horse—it was used to feed the slaves.

In more recent years there have been problems with the windows in the house—as if by some mystical force and without warning, they lower and raise themselves. Could it be the work of the Yankee officer?

On the second floor of the old house is a rocking chair that is used by what is known as the "whatever ghost." Sometimes at midnight the chair begins to rock and a lady can be heard attempting to sing Brahm's lullaby. It has been reported that she sings off-key and it sounds a lot like a dog chasing a cat.

Hanging on the wall in one of the rooms are framed silhouettes of George and Martha Washington. They are placed one above the other with George being in the upper position. Sometimes they seem to automatically switch positions.

There is a hanging portrait of Elizabeth Everhart Speers (1820–1880) that looks down at everyone in the room. This frightening thing has caused many visitors to move from one part of the room to another. But regardless of where you sit, old Liz's eyes will follow you.

In one room of the house there is a sofa that is over two hundred years old. It is known as the "dead sofa." This is where the undertaker laid the deceased for visitation viewing. In those days, the body was brought back home and members of the family sat with it around the clock until the day of burial.

As recent as 1980–1981, when workmen were renovating the kitchen they complained about cabinet and other doors opening and closing by themselves. Could it be possible that the ghost didn't like the changes being made?

Often the kids in the neighborhood talk about seeing the ghost of a slave haunting the grounds.

Grandmother Elizabeth Louisa Bruce was the last member of the Bruce family to live at Churchpoint. Members of the Speers family have occupied the house for over three hundred years.

Wildwood

This area along the Western Branch of the Elizabeth River was at one time the site of local ferry operations. The history of Wildwood began on June 24, 1809, when Brigadier General John Hodges bought one hundred acres of land along the Elizabeth River. He later built a two-room house on the property and gave it the name of Wildwood. Hodges later sold the house to a Mr. Coffman, who turned the one hundred acres into a farm and grew vegetables, which he shipped to Baltimore. The Great Depression came, and the bank was forced to foreclose on the property. After this it was rented to a Mr. Taylor, who established a gambling house on the premises. In 1939, Mr. John Kirchmier Sr. purchased the estate, and in the process of renovating the house, he found money in the fireplace. In 1963, Dr. and Mrs. Dodson bought the property from Mr. Kirchmier, who was Mrs. Dodson's father. Several additions throughout the years have changed the style of the home from its original Greek revival to the Georgian style of architecture. In 1999, the grand old home was selected by the Chesapeake Cosmopolitan Club to serve as its model for the sixth edition of the annual commemorative Christmas tree ornament.

Although the Hodges Ferry no longer exists, it still remains a part of the local history, for the present bridge along Portsmouth Boulevard is known as the Hodges Ferry Bridge. Also, across Portsmouth Boulevard stands the Hodges Cemetery where lie the remains of General Hodges as well as the unmarked graves of several slaves.

This is Wildwood, which was built on a hundred acres of land during the War of 1812. Its first owner was Brigadier General John Hodges. The original farmhouse has received many additions and renovations in the years since. The house now faces Portsmouth Boulevard. *From the author's collection.*

Poplar Hill or Brick House Farm

Located on Sterns Creek at the end of Poplar Hill Road, the farm was originally given the name Poplar Hill. The house, having been built of handmade clay bricks in 1806, stands five stories in height. A fire in 1914 was responsible for a considerable amount of damage to the interior of the house. A modern kitchen, bathroom and front porch have since been added to the original structure. For many years the grand old home was without all modern-day utilities. In earlier years, a member of the Johnson family found a brick in the fireplace. The name John Wright and the date August 10, 1807, were engraved on the brick. Like so many other articles of historic importance, the brick disappeared. It is not known if Mr. Wright built the house, made the brick or if he was a brick mason.

In 1914, the Johnsons purchased the house and farm from the Wise family. Originally the property consisted of 172 acres, but by the year 2000 the house was sitting on a 25-acre parcel.

When the property was a working farm, the main crops were white potatoes, kale, spinach, green beans, cucumbers, beets, carrots and squash. A copper stencil was used to mark the shipping containers, which were loaded on boats and taken to the docks in Norfolk where they were then forwarded to such destinations as Baltimore and New York.

Zeydron House

The Zeydron House was located on Dock Landing Road between the Glemming House and the foundation of the old Hall's Mill along Goose Creek. The house was built prior to the Civil War and served as a hospital during that late unpleasantness. This home, along with many others, lost its final battle with the interstate highway system.

The Glemming House

This site along the banks of Goose Creek on Dock Landing Road dates back to the time of the Native Americans. Thomas Meares received land grants in 1645 and again in 1649. The total of the land grants amounted to five hundred acres. Many arrowheads have been found in the yard and surrounding fields. Bricks from the colonial period and other artifacts have also been found on the site. There are elm trees on the property that have been dated to the 1600s and the 1700s.

Just prior to the Civil War, the area was producing farm products that were packaged and shipped to the Northern states. In the 1800s the Richardson family, who were wealthy truck farmers, owned the land. Other succeeding owners were the Sheldons and Lassiters.

The present house was built in 1872 and was purchased by the Glemming family in 1945. During a renovation of the house, the name J.W. Stowe and the year 1872 were found on the inside of one of the walls.

The Lilley Farm

In the early 1600s, what became the Lilley Farm was a part of the original Churchpoint Plantation. It later became the Bruce and Mackie Farms. It was in 1917 that Mr. Lilley came from Gates County, North Carolina, and bought 170 acres of the Mackie Farm.

Lilley began farming with two plow horses and was able to grow potatoes and other produce. He took advantage of the train to ship potatoes to New York. The other produce he shipped by boat to the Roanoke docks in Norfolk and from there they were shipped to Baltimore and other Northern cities. Later, with the aid of a tractor, he was able to farm 3,000 acres in the same amount of time that it previously took to farm 170 acres using his two mules.

The existing house was built in the mid-1800s, and in the 1880s a railroad was built along Bruce Road and ran from Portsmouth to Driver, Virginia. A combination train station, post office and store were also built at that time. The train station was called Bruce Station and the post office was known as Mackie, Virginia.

This is the Lilley's Lane farmhouse, which was built in the mid 1800s. This beautiful dwelling faces the water. *From the author's collection*

Western Branch

The Forrest Entrenchment

When the Civil War came to Norfolk County it played a big part in the history of Western Branch. This fort known as the Forrest Entrenchment was named for Commodore French Forrest, who was in command of the Gosport Navy Yard located at the southernmost extremity of Portsmouth. Forrest had arrived on January 22, 1861, under orders from Governor John Letcher.

This fort was located next to Goose Creek and across from Hall's gristmill. The primary reason for building Forrest Entrenchment was to protect the railhead at Bowers Hill and the mill at Hall's corner.

Sunray

The following is an early description of that part of Western Branch known as Sunray. Near the end of the nineteenth century, Polish immigrants established their own community by

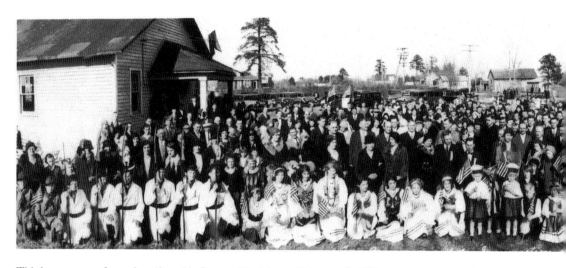

This large group of people gathered in Sunray, Virginia, on February 7, 1932, to commemorate the sixty-ninth anniversary of the insurrection of Poland. *Photograph by Acme Photo Co. Norfolk, Virginia. Courtesy of Stuart Smith.*

draining wetland and developing farms. There were some predictions in the early twentieth century that the entire area would eventually be drained for truck farms. While that never happened, today simple farmhouses of the late nineteenth century, early twentieth-century bungalows and foursquare houses can be found in the area.

Old world in appearance, this village of Poles and some Russians had as its center a tiny wooden Catholic church with stained-glass windows. Inside could be found a statue of Saint Anthony and decorative embroidery. Draped across the pulpit was a special lace-like cloth. The entire effect of this humble place of worship was one of warmth and friendliness.

Twenty years earlier this neat collection of small farms and gardens was a worthless area of swampland. The first settlers were mostly drawn from the coal mines of West Virginia. They had been attracted to what was then a worthless section by a not-so-honest land company. The men attempted to find work in the shops of the local railroads in Portsmouth, Virginia. While the men worked at regular jobs, the women and children cleared the land and developed farms and gardens.

The women continued to wear native dress and few of them could speak English. Although they worked in the fields most days, the interiors of their homes were immaculate and filled with exquisite needlework. Each window was dressed with homemade lace curtains.

An early citizen of the community was a Russian by the name of Nicholas Pavlowitz. One look at his impressive house and you knew immediately that he was an architect. Some of the other early names in Sunray were Vitez, Krace, Kazick,

Western Branch

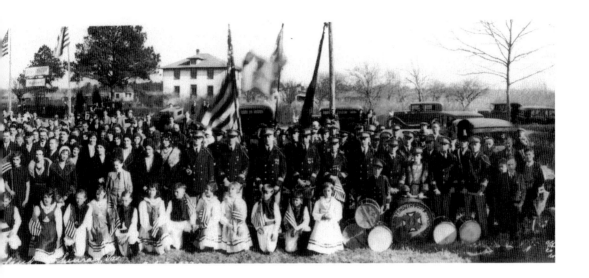

Jacovick and Penwick. The Penwick family name was the exception—they were from Yorkshire, England.

During World War II, many women began working at the shipyards, naval bases and other industries. Craney Island was a navy refueling station. What is now Tidewater Community College (TCC-Portsmouth campus) was an ammunition depot known as Pig Point. Marines were transported there from Parris Island, South Carolina, for shipment overseas. There was a German prisoner of war (POW) camp at Thalia in Virginia Beach, near where Willis Wayside is now located. The prisoners were bused daily to Western Branch farms to work. German prisoners were also used in various positions at the Portsmouth Naval Hospital. When I was a patient at the hospital, most of the servers in the dining hall were German POWs.

In earlier years, Western Branch was not only known for its vital link in the transportation of produce from the area, but also for its fish and oysters. Pollution of the Western Branch of the Elizabeth River has, for the most part, eliminated the waters that once produced an abundance of fish and large, flavorful oysters, which were harvested by local farmers and commercial watermen.

Most of the truck farms that helped feed the people of this area, as well as those of other areas, have been subdivided and given names such as Silverwood, Poplar Hill, Dunedin and Green Meadow Point. The trains no longer take on passengers, and the streetcars have since stopped running.

Western Branch, like other parts of Norfolk County, fought to avoid annexation by surrounding cities. In the 1950s, high taxes contributed to the disappearance of truck farms. The farmers could no longer afford the land taxes and so they sold out to the developers.

Residents of the city of Portsmouth soon began moving to the more peaceful neighborhoods of Western Branch, and within a few years, its population had almost

doubled. Limited access to other areas of Chesapeake was an early problem and even today it is considered a long way from the municipal center at Great Bridge. People who called Western Branch home before Norfolk County and South Norfolk merged in 1963 would hardly recognize it now. The population has more than tripled since 1970, making it (in terms of population) one of the fastest-growing areas of the city.

When traveling through Western Branch on Interstate 664, the rural feel of the area with its views of open fields, marshland and wooded areas influences one's impression of Western Branch from the west along Routes 58/460/13 and Portsmouth Boulevard (Route 337). Natural features are likewise highlighted by scenic vistas of the Elizabeth River. The river and its tributary streams serve to define and group neighborhood clusters within the area and thus contribute to a feeling of community.

Chapter XII
A New City Is Born

From where did the city of Chesapeake come? When asked that question, many will reply that there has always been a city of Chesapeake or that it is several hundred years old. Technically speaking, that is correct, but the area did not officially receive the name until January 1, 1963. Prior to that date it was the city of South Norfolk and the county of Norfolk. The merger of the two entities into one city became effective on the first day of the New Year 1963.

The next question that may come to mind is: Why the name Chesapeake? Did the city receive its name from Chesapeake Avenue in South Norfolk or the Chesapeake Bay? Actually it came from the first inhabitants of the area, who were the Chesapeake Indians. According to historic information, the Chesapeake Indians were exterminated early on by Chief Powhatan and his tribe of young bucks.

A merger referendum was held on Tuesday, February 13, 1962, and consolidation was approved. On June 26, 1962, voters went to the polls to select a name for the new city. There were twelve names on the ballot. The name Chesapeake received the highest number of votes, with Great Bridge coming in a distant second. Norfolk County had originally been referred to as the land of the Chesapeake because, as stated above, it was where the Chesapeake Indians had made their home.

There was a problem with the selection of the name though, for there was already a Chesapeake in the Commonwealth of Virginia. It was the name of a rural postal station on the eastern shore of Virginia. A deputy assistant to the U.S. postmaster general was sent from Washington to settle the conflict, but by the time he arrived, judges of the circuit court of Norfolk County and the corporation court of South Norfolk had signed orders confirming the results of the referendum. The only way the name could now be changed was through a charter change that required approval by the General Assembly. What ever happened to the other Chesapeake? The use of zone numbers, which preceded zip codes, most likely solved the problem. If the postal station on the eastern shore had won, the residents of Chesapeake would be living in the city of Great Bridge instead of the city of Chesapeake.

The birth of Chesapeake came five months after voters approved the merger of the two communities. One was a county that throughout the years had lost land, population and tax dollars to the surrounding cities; the other, a city of the first class that was free of debt and had a promising future.

In 1961, an amendment to a state law prohibited cities from annexing neighboring cities. This meant that Norfolk County properties could still be annexed, but the city of South Norfolk could not be annexed by any of the larger nearby cities. Norfolk County political leaders decided to see if they could take advantage of the change in state law by becoming part of a merger. If they were successful, it would put an end to the massive annexations by the cities of Norfolk and Portsmouth. During the previous dozen or so years, Norfolk County had lost thirty-three square miles of land, 110,448 residents, $1.88 million in tax revenue and $92.6 million in taxable property.

They approached South Norfolk politicians and arranged meetings, which began in October 1961. These meetings were held in the secluded county civic center in Great Bridge, where a court and city hall complex were under construction. The political leaders from both Norfolk County and South Norfolk met behind closed doors in a backroom of the county health department.

At the same time, merger plans were taking place between Princess Anne County and the resort town of Virginia Beach. It has been said that the media in Tidewater was preoccupied with this and none of the negotiations in Norfolk County ever reached the newspapers, radio or television. This must have been the best-kept secret in the entire state.

The early meetings were informal, and it was decided that if the group were unanimous, it would take further steps toward merger. At the third meeting a decision was made to proceed, and spokesmen from the two communities contacted the law firm of Hunton, Gay, Williams and Powell in Richmond to begin drafting the merger agreement and a proposed city charter. The firm was also preparing the merger documents for Virginia Beach and Princess Anne County.

Two weeks prior to Christmas 1961 the lawyers completed a proposed charter and a proposed merger agreement, and it was at that time that the information reached the newspapers. During the week before Christmas, the governing bodies of the county and the city held separate meetings and adopted the charter and merger agreements. There were some minor changes before the petitions were entered in the courts of both communities calling for a referendum to be held in February 1962.

Large full-page advertisements were placed in the local newspapers outlining the merger and charter provision, and a series of public hearings were scheduled throughout Norfolk County and the city of South Norfolk by advocates of the consolidation.

There were many citizens in opposition to the merger, especially in Western Branch and South Norfolk, and a lot of anger appeared at the public meetings. Some of the residents of Western Branch said that if they merged, they would rather it be with the city of Portsmouth. Those in South Norfolk who opposed the merger predicted that the city would lose everything and would be gobbled up by Norfolk County. Also a goodly number of South Norfolk citizens could see nothing to be gained by merging with the county. After all, South Norfolk was a city of the first class and could not be annexed by any of the larger surrounding municipalities.

A New City Is Born

The merger was approved. For several years afterward a story about how the new voting machines were manipulated in favor of the merger was the talk of the city. No one knows for sure if a flat-blade screwdriver was used to influence the final count. The General Assembly in Richmond granted a charter for the new city shortly afterward. After the charter was granted and before Chesapeake officially became a city, the governing bodies of the two communities met regularly to prepare for the upcoming transition.

The new Chesapeake City Council consisted of the five members of the South Norfolk Council and the five members of the county board of supervisors, who represented each of the magisterial districts of the county. A tiebreaker was appointed by the circuit court to resolve any issue that ended in a deadlock.

The South Norfolk representatives to council were Charles Richardson (South Norfolk mayor), Dan Lindsey, Howard McPherson, H.S. Boyette and Floyd Allen. Those from Norfolk County included Colon Hall, T. Ray Hassell Jr., I.H. Haywood, G.A. Treakle and Eugene Wadsworth. Charles Cross was the city clerk.

At the January 2, 1963, organizational meeting, the council elected Colon Hall as the city's first mayor, and Charles Richardson to the position of vice mayor. At the same meeting, Phillip R. Davis, who had served as city manager of South Norfolk, became the first city manager of Chesapeake. His salary was fourteen thousand dollars per year. Construction of the court and city hall buildings had been completed in October 1962. The county government had met previously at the office of the clerk of the Norfolk County Circuit Court, located off High Street in Portsmouth. South Norfolk's council had met for years on the second floor of the municipal building on Liberty Street. This building has since been demolished.

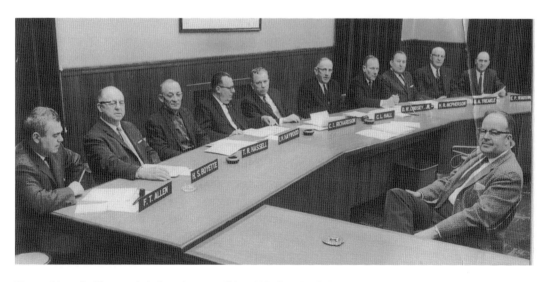

Pictured here is Chesapeake's first city council in 1963. Charles L. Richardson, *fifth from left*, was the last mayor of South Norfolk. Colon Hall, *to his left*, became the first mayor of Chesapeake. Richardson served as Chesapeake's vice mayor. The clerk is Charles Cross. *From the author's collection.*

This snowy scene in the winter of 1895 shows the Norfolk County Courthouse when it was located on High Street in Portsmouth. It remained there until the merger between Norfolk County and the city of South Norfolk in 1963. *Courtesy of the Portsmouth Central Library.*

With five members from the South Norfolk council and five from the county's magisterial districts, a power struggle soon developed. The infighting reached its peak in 1966 when two South Norfolk councilmen sought to dissolve the merger in the wake of a U.S. District Court order to reapportion council seats on a one-man–one-vote basis. This court action put an end to the five council seats from South Norfolk and was a threat to the political strength of the borough. The court ruling meant that the merger could not be dissolved. In plain words, they were told, "You created this mess, now make it work."

Chesapeake's first at-large election was held on April 26, 1966, and a nine-man ticket, led by G.A. Treakle, went into office. The election insured that Norfolk County controlled the city government. Members of the council elected G.A. Treakle mayor of the city. The county was now in control, for they not only dominated the city council, but they also held a majority of the seats on the school board. There were eleven members on the school board—six were from the county and five were from South Norfolk. The school board had been formed under the chairmanship of B.M. Williams, who had been head of the county school board. F.J. Richardson, chairman of the South Norfolk School Board, became vice-chairman. The new superintendent of schools in Chesapeake was Edwin W. Chittum, who had been the county school superintendent since 1949.

A New City Is Born

When the clock struck midnight on December 31, 1962, Chesapeake officially became a city, with 363,450 square miles of land and a population of about 75,000. It was the fifth largest city in land area in the nation. Before the merger, Portsmouth had filed an annexation suit against Norfolk County for 44.7 square miles of land in Western Branch and Deep Creek. Three days after the new city was born, a three-court judge ruled that the annexation suit was still active. For the next four years, Chesapeake and Portsmouth were in court over this land, population and taxes. In 1967, the three-member circuit court panel awarded Portsmouth 10.45 square miles of Chesapeake and 11,822 of its residents. Most of the land was in the Churchland area of Western Branch. Chesapeake's losses also included three schools, 45 miles of sewer and waterlines, a library branch, a fire station and the West Norfolk Bridge.

The court ordered Portsmouth to pay Chesapeake $10.9 million. The money was used to help pay for capital improvements, which included a sewer and water system, four new schools, street and highway improvements and a main library.

Voters approved a $26.5 million bond referendum in November 1969. This allowed the city to extend its waterlines and to finance its own water system. The opening of the Northwest River water treatment plant in 1979 marked another step towards independence from the surrounding cities. Until then, local water resources had been totally controlled by the cities of Norfolk and Portsmouth. The plant was initially designed to supply up to ten million gallons a day to city customers. Another event of importance was the opening of the $10 million high-rise bridge over the Southern Branch of the Elizabeth River in 1965. It was the last segment of the Interstate 64 construction project that linked Chesapeake residents with Norfolk, Portsmouth, Virginia Beach and Suffolk.

In 1963, a large part of what is now Chesapeake consisted of farms and woodlands. The city began with a population of about 75,000. Today the population is 218,438 and is still growing. Chesapeake is now a large, sprawling city.

Chesapeake— Past, Present and Future

This is where we look back at a few things that have taken place, some recent happenings and changes that we hope will take place in the future. At the time of this writing the city of Chesapeake is almost forty-five years old, but in reality it goes back much further than the year 1963, when Norfolk County and the city of South Norfolk merged.

There are landmarks and communities within the city that date back to around 1620. It was in 1661 that the first Southern Branch Chapel was built in the vicinity of present-day Lakeside Park. There are houses still standing that date back more than 240 years. The city may be young, but the roots from which it sprouted are among the oldest in the nation.

The needs and desires of the citizens are many. But how big is too big? Services such as schools, roads, transportation, public safety, medical facilities and places to shop are among the bare necessities. There are literally dozens of schools. At this time there are seven high schools; the new Grassfield High School opened in the fall of 2007. A new Oscar F. Smith Middle School is under construction on Rodgers Street.

This April 1973 photograph shows a few of the stores in the Great Bridge Shopping Center. *From the author's collection.*

On Saturday, February 10, 2007, the new Dr. Clarence V. Cuffee Library opened at 2726 Border Road, bringing the total to seven libraries throughout the city.

Prior to the formation of the city of Chesapeake, each area post office had its own handstamp, which was used as its postmark. Bowers Hill, Hickory, Fentress, St. Brides, Deep Creek, Great Bridge, Buell, Portlock Station, South Norfolk and Camden Mills are examples of stations that had their own rubber stamp. Camden Mills later became Bells Mill and Buell became Portlock Station.

Beginning in 1884, postboxes (or mailboxes) were installed on many street corners throughout small towns and cities. They were mounted on concrete posts, and the boxes, painted olive drab, had a small slot at the top with instructions to "pull down." Home delivery of mail was made twice a day, six days a week.

Sunday deliveries were made the week before Christmas, and the post office department hired additional personnel to work during the busy month of December. It was a great way to earn college tuition. The main post office on Battlefield Boulevard was dedicated in 1967. Although the post office is still there, a new main station was later built at 1100 Battlefield Boulevard South near Hanbury Road.

A New City Is Born

Chesapeake General Hospital— Chesapeake Regional Medical Center

In the 1950s, Mayor Briggs and members of the South Norfolk City Council recognized the need for a hospital; however, their plans were not realized before the merger with Norfolk County took place in 1963. In 1965, the story of Chesapeake General Hospital began. It was a tremendous community effort that was led by Dr. W. Stanley Jennings. Jennings stated that "we had waiting lists to get our patients into the Norfolk hospitals, so it seemed logical that we needed one of our own." In March 1966 the General Assembly of Virginia enacted legislation that established the Chesapeake Hospital Authority, which serves as the governing body of the hospital.

Efforts to finance construction of the hospital began in 1969 with a public bond referendum for $2.4 million. A fundraising committee was established in 1972. In May 1972 the authority received a million-dollar grant from the United States Department of Health, Education and Welfare.

In April 1973 construction of a 106-bed hospital commenced; however, in December of that year it was realized that additional beds would be needed. With that in mind it was decided to complete the third-floor shelled-in area, which would accommodate 32 more beds. Also, at that time a decision was made to add a fourth-floor shell, which would accommodate another 69 beds at a later date. Realizing the growth potential of the city, plans were made to provide future expansion to 350 beds.

Occupancy of the hospital occurred in phases with the first two floors being occupied in December 1975 and the complete hospital being placed into service in January 1976.

Donald S. Buckley, who started with thirty-five acres of woodland, a blank sheet of paper and a trailer office, was the first president of Chesapeake General Hospital—now Chesapeake Regional Medical Center. Dr. Buckley retired in 2005 and was succeeded by Chris Mosley.

Chesapeake's Museum and Information Center at 3815 Bainbridge Boulevard has been replaced by the Portlock Gallery, which is supported by the city of Chesapeake. Two city offices that were previously quartered at the Chesapeake Conference Center have relocated to the gallery.

Renovation of the Captain Frederic E. Consolvo Jr. Armory was a hot topic for a while. A citizen's group was going to restore the building and then return it to city. Once renovated it was felt that it, along with the five acres of land, could be used as a multipurpose center to serve the senior citizens and youth of the community. This plan fell through and then the Boys and Girls Club of America signed a five-year lease; however, in order to make the building usable it would be necessary to raise at least a million dollars. That has not happened to date, and the building continues to deteriorate. Most likely it will be demolished.

On February 27, 2004, the new five-lane bridge at Great Bridge was opened for traffic. It was a cold, windy Saturday and those on hand gathered under a large tent at the foot of the bridge and listened to numerous political speeches.

Construction of the Chesapeake General Hospital began in April 1973. Occupancy occurred in phases with the first two floors being occupied in December 1975 and the complete hospital was placed into service in January 1976. *Courtesy of the marketing department of Chesapeake General Hospital.*

On October 19, 2006, members of the Money Point Task Force met one last time to celebrate two years of work in formulating a plan to clean up the pollution in the Elizabeth River and also plans for a major cleanup along the waterfront. Eventually this became a joint effort of the University of Virginia Institute for Environmental Negotiation, the Elizabeth River Project and the industries at Money Point. The celebration took place at the LaFarge Cement Plant at Money Point. Several trees were planted by a group of concerned youth.

About a year ago the old Grand Theatre and other boarded up buildings in the 1000 block of Chesapeake Avenue were bought by Jeffrey T. Sadler. Jeff has plans to restore the theatre and other buildings along Chesapeake Avenue.

In the year 2006, the stadium at Oscar F. Smith Middle School was demolished and preparations were made to erect a new middle school where the stadium once stood. The groundbreaking ceremonies were conducted on Thursday, September 13, 2007.

After taking some time off to reorganize, the Chesapeake Art Show will return to Lakeside Park in South Norfolk on April 26 and 27, 2008. The show will feature the work of over fifty local and regional artists in a wide array of mediums. In addition to the art, there will be live music, children activities and festival food both days.

A New City Is Born

The new five-lane bridge on Battlefield Boulevard at Great Bridge opened on February 27, 2004. *From the author's collection.*

This tree planting took place at Money Point on October 19, 2006. It was part of the final meeting of the Revitalization Task Force that had its beginning in May 2004. It seems everyone was taking pictures, even Princess Elizabeth and yours truly. The task force put together a ten-year plan to clean up the Elizabeth River. *From the author's collection.*

This drawing is part of the plan to restore the old abandoned buildings in the 1000 block of Chesapeake Avenue. The large structure on the right is a vision of how the old Grand Theatre could possibly look after renovation. *Drawing courtesy of Jeff Sadler.*

From 1731 until 1859, deceased members of the Massenburg family were buried on this land that has in recent years served as the stadium for the Oscar F. Smith School. The land is now being prepared for construction of the new Oscar F. Smith Middle School. *From the author's collection.*

A New City Is Born

These were just a few of the exhibits at the Lakeside Park Art Festival on September 17, 2005. The Fourth Annual Chesapeake Arts Show will return to Lakeside Park on April 26–27, 2008. *From the author's collection.*

The Ripken Baseball Tournament Series took place in Aberdeen, Maryland, on Mother's Day 2007. *Left to right*: (*first row*) Brett Moulton, Robbie Semonich, David Shivly, Kyle Bush and Danny Alexander; (*second row*) William Breedlove, Brian Miller, Matthew Trotman, Colby Rudis and Trevor Riggs; (*third row*) Coaches Bob Bush and Mike Semonich. *Photo courtesy of Colby Rudis.*

155

On September 19, 2007, at 11:30 a.m. a groundbreaking ceremony was held at the infamous "Big Pig" property at the corner of Poindexter Street and Bainbridge Boulevard.

Let's not forget the Chesapeake Blasters and all the other little league teams. The kids work and play hard and possibly one day in the not so distant future some of them will play in the majors. The big leaguers have to start somewhere!

Bibliography

Books

Chandler, Julian Alvin Carroll, ed. *The South in the Building of the Nation. Vol. I. History of the States*. Richmond, VA: The Southern Publishing Society, 1909.

Harper, Raymond L. *History of South Norfolk: 1661–1963*. Chesapeake, VA: Self-published, 1994. Revised 1996.

_____. *Images of America: Norfolk County*. Charleston, SC: Arcadia Publishing, 2000.

_____. *Images of America: South Norfolk*. Charleston, SC: Arcadia Publishing, 1999. Reprinted 2002.

_____. *Making of America: Chesapeake, VA*. Charleston, SC: Arcadia Publishing, 2002.

_____. *South Norfolk, Virginia, 1661–2005: A Definitive History, Vols. I and II*. Charleston, SC: The History Press, 2005.

_____. *South Norfolk, Virginia, 1661–2005: A Visual History, Vol. III*. Charleston, SC: The History Press, 2006.

_____. *Then & Now: South Norfolk*. Charleston, SC: Arcadia Publishing, 2003.

_____, with Raymond T. Jones. *Good Old Golden Rule Days*. Chesapeake, VA; Self-published, 2003.

Porter, John W.H. *History of Norfolk County: 1861–1865*. Portsmouth, VA: W.A. Fiske, 1892.

Bibliography

Tyler, Lyon Gardner, ed. *Encyclopedia of Virginia Biography. Vols. I and II.* N.p.: Lewis Publishing Co., 1915.

St. Paul's Church 1832, originally The Borough Church 1739—Elizabeth River Parish, Norfolk, Virginia. Norfolk, VA: Altar Guild of St. Paul's Church, 1934.

Articles

Chesapeake Clipper, August 6, 1987.

Daily Southern Argus, May 13, 1848.

Ledger Star and *Virginian-Pilot*, November 13, 1986.

TIPS Weekly, February 26, 1898. Berkley edition.

Minutes and Miscellany

Information for this book also came from the following:

Butt, Halstead, Herbert, Hunter, Portlock, Tatem, West and Wilson family Bibles.
Chesapeake Health. *Vital Signs*. Chesapeake General Hospital December, 2000.
Colonna Papers. Volume I, July 1988. Volume II, May 1996.
Norfolk County, Its History and Development—The Leading County of Virginia. Author and publisher unknown.
Norfolk County records.

About the Author

Author and historian Raymond L. Harper is a lifelong resident of South Norfolk. He is a veteran of World War II, having served the United States Navy in the Pacific Theater. He received his formal education from the public schools of the city of South Norfolk, the College of William and Mary, Virginia Polytechnic Institute and State University, Old Dominion University and Weber State University. He retired from federal service in 1988 after more than thirty-two years.

He served the City of South Norfolk, the City of Chesapeake and the Commonwealth of Virginia in several capacities, including as president of the Chesapeake Museum Board of Directors, a commissioner on the South Norfolk Revitalization Commission, the City of Chesapeake fortieth-anniversary committee, Jamestown 2007 committee, Poindexter Street Technical Advisory Committee for the City of Chesapeake, Reflections Program for the Oscar Smith School, the School Improvement Action Team for the Rena B. Wright Primary School, advisor to the Institute for Environmental Negotiation, University of Virginia Graduate School, and he was appointed to the City of Chesapeake Library Board on February 10, 2007. Died 6 Feb 2022

visit us at
www.historypress.net